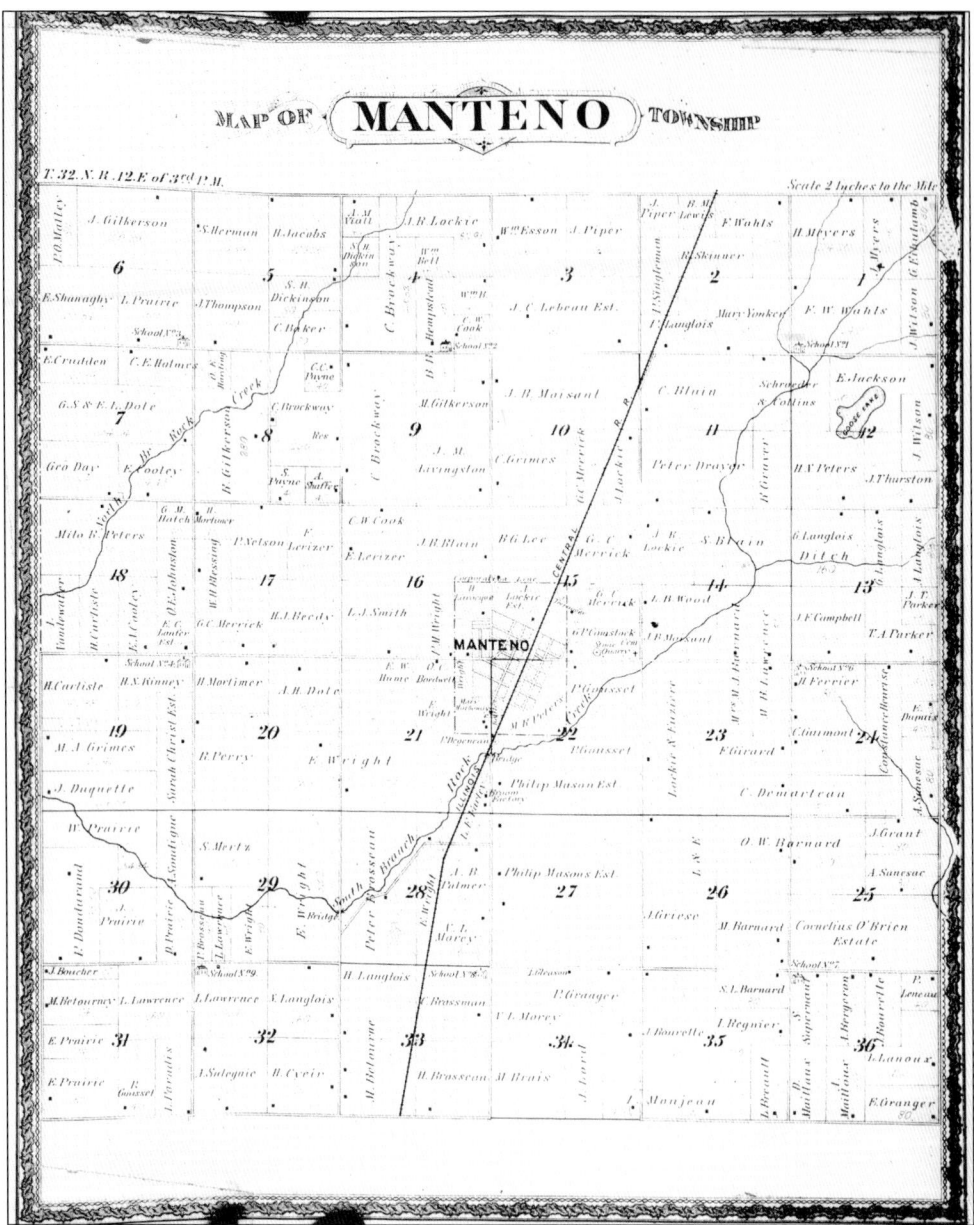

This 1883 map of Manteno Township shows a six-mile square divided into 36 square-mile sections, each consisting of 640 acres. The "Original Town" was laid out in the northwest corner of section 22. The middle of the township is where sections 15, 16, 21, and 22 meet (Section Line Road and Maple Street). (Courtesy of Manteno Historical Society's Manteno-Rockville Museum.)

ON THE COVER: Henry and Phoebe (Rahm) Stauffenberg purchased farmland northwest of the village from Robert and Agnes Gilkerson. Henry and Phoebe's son Albert moved to the farm with his wife, Helen (Hanson), in 1907 and raised three children—Leona, Lester, and Donald. Pictured around 1913 from left to right are Leona and Lester (on the horse), Helen (holding the rein), an unidentified woman and baby, Albert, and an unidentified man. Stauffenberg descendants still own this farm. (Courtesy of Susan Stauffenberg LaMore.)

IMAGES
of America
MANTENO

Melanie Holmes

Copyright © 2020 by Melanie Holmes
ISBN 978-1-4671-0448-7

Published by Arcadia Publishing
Charleston, South Carolina

Printed in the United States of America

Library of Congress Control Number: 2019949365

For all general information, please contact Arcadia Publishing:
Telephone 843-853-2070
Fax 843-853-0044
E-mail sales@arcadiapublishing.com
For customer service and orders:
Toll-Free 1-888-313-2665

Visit us on the Internet at www.arcadiapublishing.com

This book is dedicated to my mother, Nedine (Lemenager);
siblings Steve, Marla, Paul, and Mary;
parts of my heart Rob, Kevin, Adam, and Morgan;
and extra "sisters" the Goss girls.

CONTENTS

Acknowledgments 6

Introduction 7

1. The Potawatomi of the Prairie and the Kankakee 9
2. Illinois Central Railroad and the Founding of Manteno 15
3. Farms and Related Businesses 21
4. Churches and Schools 41
5. Main Street Merchants 77
6. Around Town 91
7. Manteno State Hospital 119
8. Packard Laws 131
9. The Railroad's Impact 137
10. Small Town, Big Future 145

Bibliography 159

Acknowledgments

Other historians' words were set in ink before the writing of this book, including those of Evelyn Viall, Madge Merwin, Virgil Guimond, and my Aunt Mildred (Bowman Minnich LaBeau). Their work was priceless to my process. Many people trusted me with family photographs; some invited me into their homes, others let me tag along down memory lane as they spoke—a magical journey. It was the smiles in their eyes or voices that propelled this work forward.

If a town is lucky enough to have a historical society, it is indeed fortunate. Manteno was 117 years old when one was formed in 1986. Anthropologist Margaret Mead said, "Never doubt that a small group of thoughtful, committed citizens can change the world; indeed, it's the only thing that ever has." The historical society's curators have made (and continue to make) a huge difference for those in search of an ancestor, or children who walk through the society's one-room schoolhouse. Certainly, the townships of Manteno and Rockville are better for having people who honor history, for the past informs the present and the future.

Cindy (Blair) Simmons, your patience and passion shine in all you do—thank you. Jeff, Jerry, and Kay Jarvis, for answering my emails/questions and giving sound counsel before this went to print. To Jack Klasey, historian extraordinaire, you are one of the giants, truly. My great Arcadia editor Caroline Anderson, thank you for responding to 258 emails over the past year!

Following are a few others who contributed to this book—Kevin Brown, Jorie Walters, Sister Yvonne Brais and others with the Servants of the Holy Heart of Mary, three Stauffenbergs (Jim, Mark, and Sue), Vic Johnson (another history "giant"), George Godfrey for allowing me to use his grandmother's image, my cousin Martha Minnich O'Connor, classmate Bryan Spangler and his wife Leotta (Plumley), Chris Russell, Nancy (Wulff) Kaufman, Franklin Weber, Norma Meier, Jamie Lockwood, Courtney Posing, and Elmira Wilkey. There are too many to list; so many answered history's call. Thank you all.

Thanks also to Paul Keigher and Jerry Jarvis for helping dispel the long-held rumor about Manteno High School's lack of a football team for 57 years. With this writing, the rumor is put to rest.

A number of images in this volume appear courtesy of Manteno Historical Society's Manteno-Rockville Museum (MHSMRM) and Kankakee County Museum Photo Archive (KCMPA).

Introduction

Manteno would not have blossomed in the mid-1800s if not for the Illinois Central Railroad's (ICRR) decision to build Manteno Depot in 1853. Construction of the railroad was made possible through real estate sales along the lines; thus, it became ICRR corporate strategy to establish depots in unincorporated areas so that the company could sell plots of land to settlers along its rail lines. The plan worked—between 1852 and 1856, ICRR laid 706 miles of track, making it the longest line in the world at the time—and Manteno (and similar settlements) grew up out of the soil. The train towns prospered because ICRR linked them with markets north to Chicago and as far south as New Orleans. This synergistic arrangement did not last. Manteno thrived, but the station was closed about a hundred years after the village was established. And at the end of the 20th century, ICRR was absorbed by a Canadian train line.

Of course, the township's history began before the railroad. The story stretches across vast prairies with fertile land for crops, and waterways with timber growing alongside for homes—these geologic features drew First Nations peoples and Europeans alike. Although the names of other tribes arise when discussing the area, such as the Miami or Illini, it was the Potawatomi who built homes and hunted and lived here just prior to the arrival of the white man. The Potawatomi were displaced by pioneers after the passage of the Indian Removal Act of 1830, which gave the president power to negotiate treaties that would "entice" (or force) tribes to exchange their lands east of the Mississippi for lands to the west. Although Pres. Andrew Jackson originally eyed southeastern lands such as Georgia and Florida, the Indian Removal Act also affected tribes in the north. Among the Potawatomi were names known to today's area residents, such as Mawteno Bourbonnais (granddaughter of Francois Bourbonnais Sr.), whose name contains two local appellations that are easily recognizable. Many Potawatomi words were used when naming lands and waterways in this area. Theakiki (Potawatomi for wonderful land) evolved into Kankakee—the name chosen for the railroad's depot, also given to the city that became the county seat, as well as to the great river that runs near present-day Manteno Township.

French explorer LaSalle passed through what would become Kankakee County, having traversed the Kankakee River in 1679. But it was the opening of the railroad in 1853 that drew a rush of pioneers to the area. Just two years later, in 1855, Manteno Township was formed. And in 1869, the village of Manteno was incorporated.

With Lake Michigan and Chicago to the north, the Kankakee River to the south and west, and Rock Creek running through the village, it seems Manteno was destined to bloom. Much has taken place in this small town with a big future in its 150-plus years. What was once a three-block-wide plat of land with not much more than a train station evolved into a thriving agricultural center. Mantenoans' experiences have been quite varied. Past residents saw cattle and hogs traverse the streets between a livestock yard on the north end of town to a farm on the south end. They saw the great fire—the burning of the business district before a reliable water supply could extinguish the flames. They also saw (or heard of) underground taverns during

Prohibition, a mobster hideout a few miles north, a rumored house of ill-repute on the southern edge of town, one of the world's largest mental institutions to the east, and to the west a major interstate that connected Manteno to other busy byways. In town, public schools multiplied, and a Catholic parochial and boarding school drew students from near and far. And surrounding the village, in all directions, were farms.

Villagers called themselves Mantenoites from the 1800s through the 1950s. The term "Mantenoan" did not appear in the *Manteno News* until the 1960s. Whatever people call themselves matters less than what it means to be from Manteno—the context of which has changed over time. From a magnet for French-Canadians to the grain capital of the state, to a town with a state hospital on its perimeter that was referred to by Chicagoans as simply "Manteno." As with much of history, certain parts of Manteno have faded from view, but what *was* is sewn into its fabric.

There is a language—"Mantenoese," if you will—that is understood by those who have lived within its boundaries a long time. Newcomers can feel lost or left out when certain topics come up. When the old brickyard is mentioned, or the fact that nuns were once a common sight in town, long-timers nod their heads. Talk of the Phipps farm elicits certain images, such as a tree-lined lane that extended west from Elm Street (an extension of the half-block Lane Drive, so named since it was part of that farm's "lane" before the town encroached upon it), and after reaching the Phipps farmhouse, seeing crops or cows in all directions. The old Phipps home is still there, but houses and a school now surround it; Poplar Street was extended south so that its address is no longer Elm, it is 255 South Poplar. Likewise, certain roads headed out of town are identified with certain nomenclature that Mantenoans instantly understand. Each town has its own culture. A young person growing up here today, with several chain businesses, may see a "Walmart and McDonald's" atmosphere, but to live in Manteno is to be surrounded by a vibe born of generations of hard-working, hopeful, caring people who drive 20 miles per hour on almost all village streets, and people honk in recognition, not anger. Sometimes one doesn't realize just how unique Manteno is until, after leaving and dwelling elsewhere, they return with new eyes. The town, no matter how different from a decade (or five) ago, elicits a feeling of home.

The faces of Manteno change, yet remnants of countless families remain. Just because a person does not bear the name Butler or Minnich or Baird or Monnette or Boisvert does not mean they do not descend from one of those lines. For those with deep roots in the village, puzzle pieces of their past are found along Manteno's streets or at the bottom of an old brickyard. As for residents whose roots began elsewhere, the stories continue to intertwine, and the nature of the town is enhanced by each addition to the picture. And for those who have moved away, they may agree that Manteno is as much a mindset as it is a place.

One

The Potawatomi of the Prairie and the Kankakee

Before Europeans arrived in what is now northeast Illinois, the Potawatomi of the Prairie and the Kankakee populated the area; thus, their language came to dapple the land as white pioneers named towns and rivers for those who came before them.

The early 1800s saw marriages between fur traders and Potawatomi women as a means to cement relationships between trading partners. French Canadian fur trader Francois Bourbonnais married an unnamed woman who bore him a son—Francois Bourbonnais Jr. This son went on to have a daughter, Mawteno Bourbonnais—from whom Manteno derives its name. Since the Potawatomi language was written phonetically, variations occurred. Mawteno became Manteno, and later, the town's French culture led to Manteneau, a translation that graced school yearbooks for decades.

It is not known how many marriages took place between fur traders and Potawatomi. Two notable marriages left their mark on the area. Gurdon S. Hubbard and Noel LeVasseur were both in turn married to the Potawatomi woman Watchekee. Hubbard had come to the area to establish a trading post in what is now Iroquois County, and married Watchekee during his time at the post. When he moved to Chicago, he divorced her. Hubbard's assistant, Noel LeVasseur, replaced him at the trading post, and soon married Watchekee. With the Indian Removal Act came treaties that meant the removal of native peoples to land west of the Mississippi River. By 1832, hundreds of Potawatomi were removed to Council Bluffs, Iowa. By 1836, LeVasseur was appointed agent in charge of overseeing removal from this area. His wife, Watchekee, followed her family westward, but LeVasseur did not. Instead, he bought tracts of land made available for sale by the treaties and established a settlement that became current-day Bourbonnais—part of Kankakee County. Although many fur traders parted with their Potawatomi wives, not all did. Francois Bourbonnais Sr. had married the Potawatomi woman Catish and had more children; he went west with his family, leaving behind only his name.

With the Potawatomi removed, homesteaders and businesses came in droves.

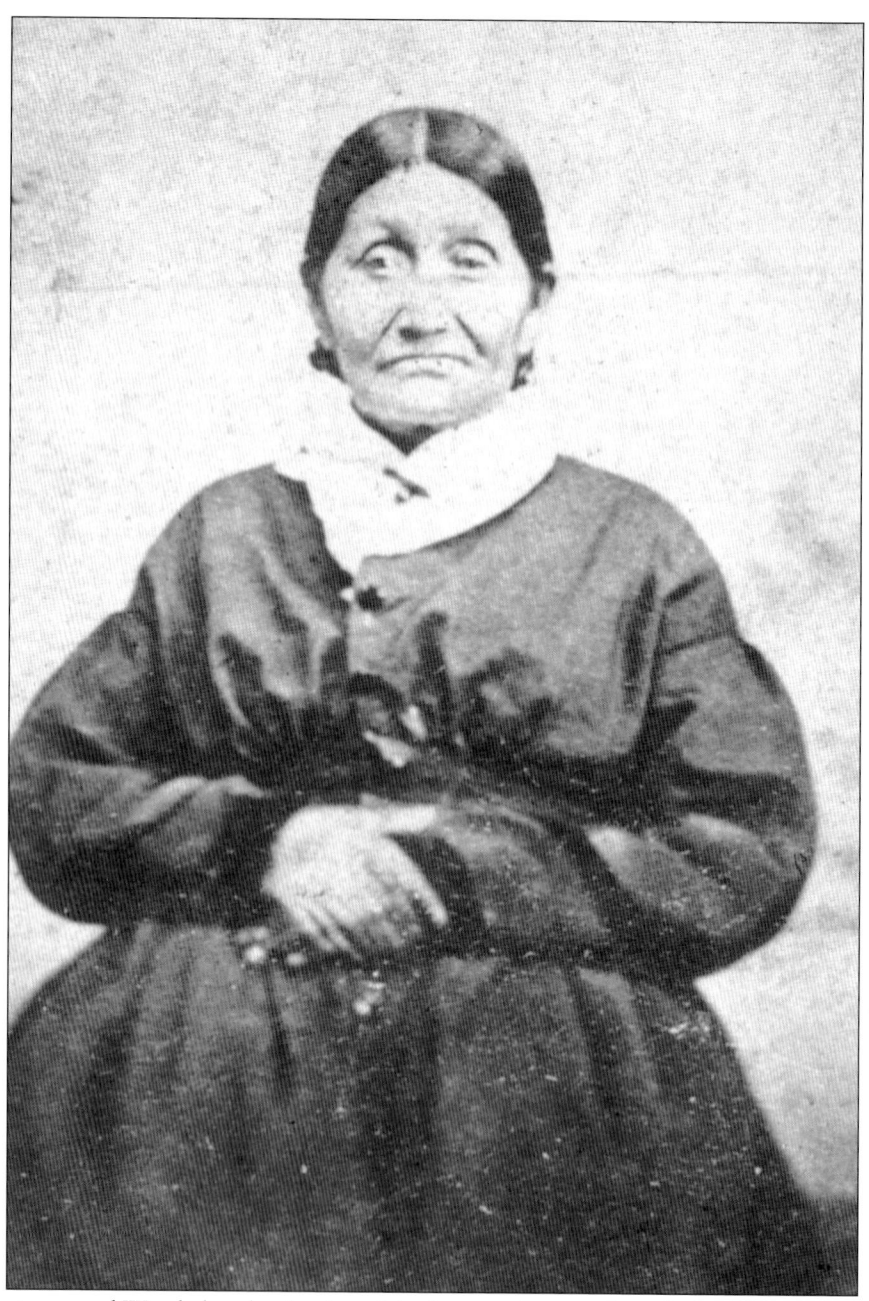

Shown is an aged Watchekee; by the time this photograph was taken, she had been married and divorced two times, had left her home near the Kankakee River, and had settled in Council Bluffs. The people of Iroquois County remembered Watchekee for her kindness during the "winter of deep snow," which is why South Middleport was renamed when it became Iroquois county's seat in 1865—to Watseka, an anglicized variation of Watchekee. When Watchekee departed for a new home west of the Mississippi, some say Noel LeVasseur divorced her; however, when she arrived in Iowa, she was classified as a "Grass Widow" (abandoned by her husband). She later returned to the Bourbonnais area, and during her visit, Francis Bergeron married her and went west with her. Watchekee Bergeron died about 1872. (Courtesy of George Godfrey.)

Gurdon S. Hubbard (right, around the 1870s) and Noel LeVasseur (below, around 1870) came to the area in the 1820s as fur traders. Hubbard ran a trading post on the Iroquois River beginning in 1822 and wore a path that became known as Hubbard's Trail as he established posts south of Iroquois to Danville and north to Chicago. That trail later became Route 1 and leads to Chicago's State Street. Hubbard chose as his assistant Noel LeVasseur, who took over the Iroquois post and moved to the area along the Kankakee River, establishing the settlement that became Bourbonnais, of which LeVasseur is considered the founding father. (Both, courtesy of KCMPA.)

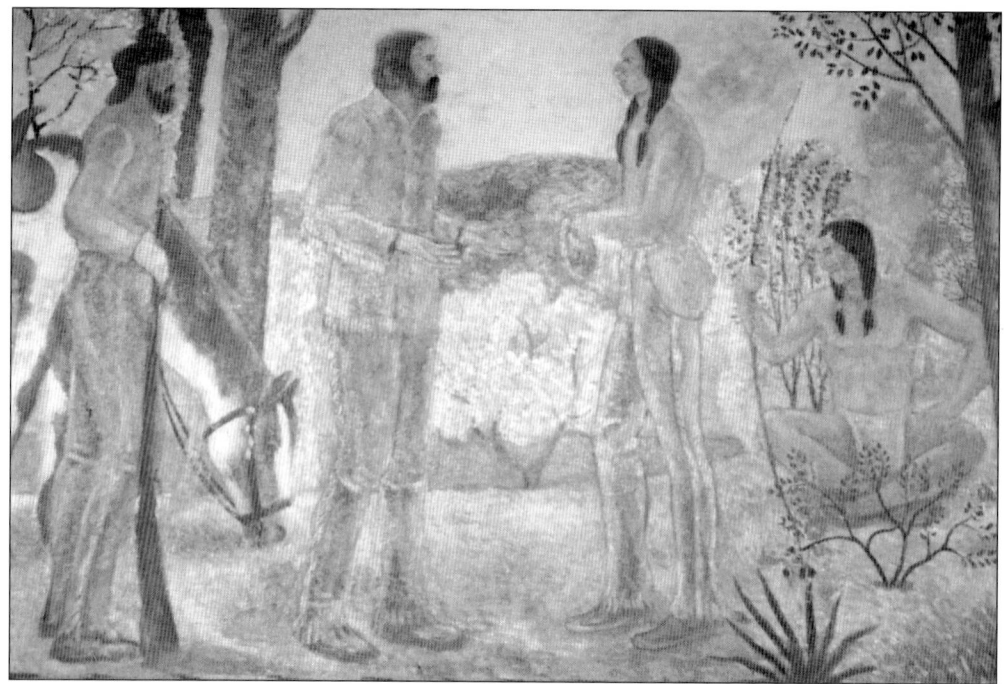

The Works Progress Administration funded the only government-sponsored art program in American history, which enabled this work to be created. It depicts the Potawatomi meeting with white Euro-Americans to exchange goods. Though the Potawatomi's clothing may appear genuine, First Nations people shed their custom of wearing animal skin and donned European shirts with collars and buttons. Potawatomi men wore turbans; women wore shawls and scarves. These "Manteno Murals" originally hung in the Manteno State Hospital's regal administration building; they now hang in the Manteno Historical Society's museum. (Courtesy of MHSMRM.)

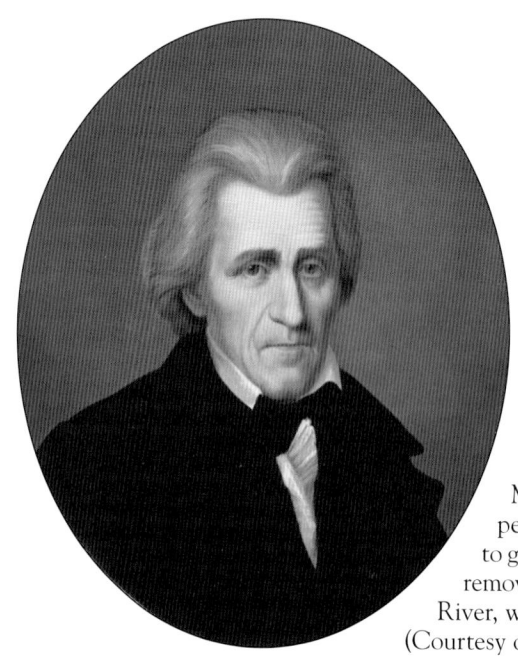

One of the first pieces of legislation Pres. Andrew Jackson pushed through Congress was the Indian Removal Act, which he signed May 28, 1930. His disregard for First Nations people was well known; he thought them unable to govern themselves. What followed was the forced removal of eastern tribes to the west of the Mississippi River, with the tragic loss of innocents in the process. (Courtesy of Library of Congress.)

This stone on the Kankakee County Courthouse's east lawn was placed by the Kankakee Women's Club to mark "the last camping ground" of the Potawatomi in 1853. Kankakee sits on land vacated by the Potawatomi when they removed to the west. A young Henry S. Bloom wrote of seeing a group in summer 1836 as they camped on his father's Rockville farm before they headed west. Bloom saw "tears in the eyes of many," and thought they were a "badly treated race." (Author's collection.)

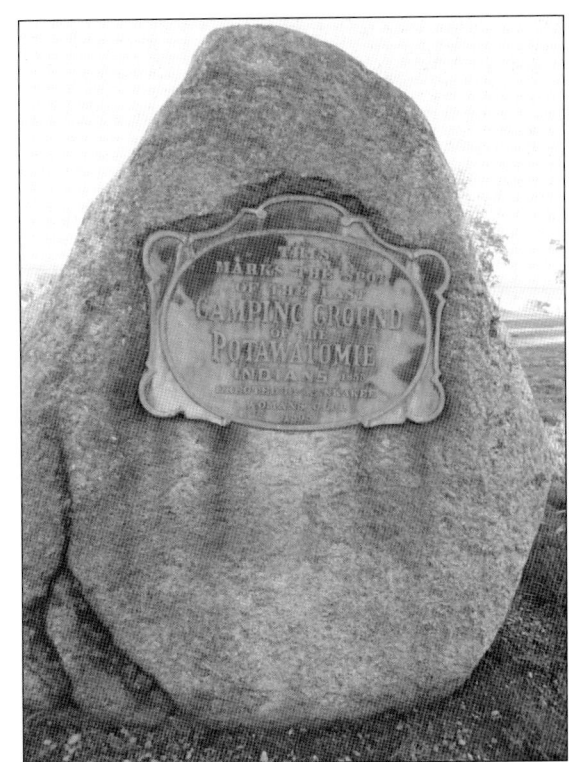

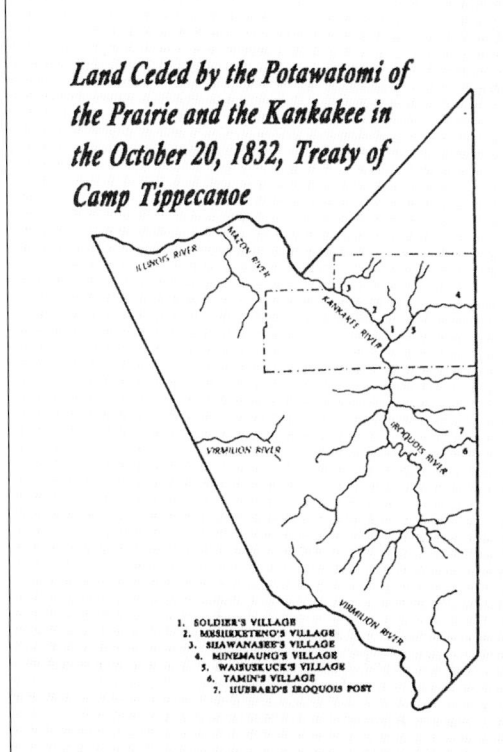

This map shows the area affected by the Treaty of Camp Tippecanoe, signed on October 20, 1832. Mawteno Bourbonnais's reserve was at Soldier's Village, where much of the city of Kankakee now stands. The treaty describes the area ceded: "a point on Lake Michigan ten miles south of the mouth of the Chicago River" to a point on the Kankakee River ten miles above its mouth; included is a boundary from a cession made in 1816, as well as the Indiana-Illinois state line. (Courtesy of Vic Johnson.)

IMPORTANT TO WESTERN EMIGRANTS.

FOR SALE,

8,000 ACRES OF LAND, ALL INDIAN RESERVATION BY THE POTAWATAMIE TREATY OF 1832.

3200 Acres were located, by treaty, on the North Bank of the Kankakee River, at the mouth of Rock Creek, in Will County, Illinois, for Shawwanassee, a Potawatamie Chief, to include his former residence and Village, and familiarly known as the Rock Village, or Shawwanassee Reservation. It is situated ten miles above Wilmington, a flourishing Village on the Kankakee, where a Feeder must be taken for the Michigan and Illinois Canal, through which boats may pass from the Canal to this place.

This tract has never failed to elicit the admiration of all (perhaps the envy of some) who have visited this country. Its situation is elevated, dry, and gently sloping to the River and Creek which runs through it. The soil is unsurpassed in fertility by any between the Green Mountain and the Mississippi River. It embraces about 1200 Acres of Timber; plenty of Limestone, of superior quality for building, and is well watered by Springs and small Branches for the convenience of Stock raising. The River for twenty miles above and below is generally rapid, its bed and bank of Limestone and Marble, is susceptible of easy improvement at this place, and is considered by good judges, equal, if not superior, for hydraulic purposes, to that of Rochester, in the State of New York. Here is also a beautiful town site, where a Post Office is established; and upon the Creek near by is a Saw-Mill erected and in operation---and a town will be laid out in Lots, and offered for sale the coming summer.

The farming portion is surveyed into tracts varying in size from 20 to 200 acres, each being supplied with timber, and most of them with permanent water.

The other lands were floating grants, selected in 1835, with care, and approved by the President in February last. Three half-sections are adjoining the Rock village tract, 2500 acres at and near the mouth of the Iroquois River, and the balance at the head of the Rapids of the Kankakee River, about fifty miles south of Chicago, where the State Road crosses the River from Vincennes and the lower Wabash country to Chicago. A Post Office is established here called Lorain. Here also is water power equal to any in the West. A Dam and Saw Mill is erected on the premises, and a Flour Mill in course of erection for three run of stone, will be completed by the 1st of October next. From this point upwards, the River has no obstruction to the passage of light-draught steamboats, for 80 or 90 miles, to within a short distance of the St. Joseph River. Here also is a beautiful and healthy site, which has ever been considered as emphatically The Place for a town, and in accordance with the general sentiment, the proprietors have recently laid out a town called Momence, the name of the original Indian Reservee, the lots of which are offered at private sale, together with all the property here described, in tracts or quantities to suit purchasers, by the Subscriber, who will be pleased to answer any Communications on the subject, Addressed to him at *Rockville, Will County, Illinois.*

HIRAM TODD.

P. S.---It is well known by those acquainted with Indian Reserves, that they are the choice of the whole surrounding country, both as regards health, and beauty of locality, and quality of the land, whilst every one knows the partiality of the Aborigines of our country for the best forest land.
Rockville, Will Co., Illinois, April 22, 1845.

REFERENCES:

A. G. HOBBIE, Esq.;
R. L. WILSON, Esq.; } CHICAGO, ILL.
Hon. THEOS. W. SMITH,

THOS. G. ALVORD, Esq., SALINA, Onondaga Co., N.Y.
Col. WM. GOODING, Lockport, Will Co, ILL.
HENDERSON & WILSON, Att'ys, JOLIET, ILL.

ELLIS & FERGUS, PRINTERS, SALOON BUILDINGS, CHICAGO, ILL.

With the Treaty of Tippecanoe of 1832, Hiram Todd traveled to the Kankakee River Valley and purchased enough land to make him the largest private landowner by 1845—he had secured 8,000 acres for prices as low as $1.21 per acre (some reservation lands sold for $16 per acre just four years later). This flyer was printed by Todd to entice emigration from the east. Todd had obtained his physician's license in Ohio, then moved in 1828 with his wife, Lydia Church, to Logansport, Indiana, along the Wabash River. There he found a largely Potawatomi population in need of medical attention; most physicians would not minister to them. Todd became known as the "White Medicine Man." In 1845, he built a home for his family near Rock Creek in what later became Rockville Township. The White Medicine Man enjoyed his home only a short time; his death from "consumption" (tuberculosis) in 1849 cut his life short. (Courtesy of KCMPA.)

Two

Illinois Central Railroad and the Founding of Manteno

Western rail expansion came to Illinois in the 1850s. At the beginning of that decade, Illinois had 111 miles of railway line; by the 1860s, the state boasted 2,790 miles of rail. It all started with an unprecedented land grant approved by Congress in September 1850, whereby the federal government granted public lands in order to encourage private construction of a major rail line. The Illinois Central Railroad (ICRR), chartered on March 19, 1851, with Robert Schuyler as president and David Neal as vice president, became one of the longest railroads in the world after just five years. But the ICRR was unable, officially, to lay out townsites because the original charter prohibited the company from doing so. Evidence points to David Neal, who along with other investors formed the Associates Land Company for this express purpose. With Neal's advance knowledge of the selected route for the line, the Associates purchased several plots of land upon which depots were later located.

In fact, it was Neal who filed a plat for the town of Manteno in late 1854, which covered one and a half blocks east to west and three blocks north to south on either side of the tracks. Shortly thereafter, with restrictions lifted, the ICRR filed a plat for an addition to Manteno of similar size to Neal's plat. What began as Manteno Depot in 1853 evolved into Manteno Township in 1855, followed by the incorporation of the Village of Manteno in 1869.

When railroad agent Edmund Jackson built his home near Manteno Depot, he found very little in the way of a settlement. Early white settlers dotted the area, but the person credited as Manteno's first merchant is Medard Martin. After Martin and his wife, Marguerite, established a store, Frances Tompkins opened a blacksmith shop; these two businesses were the seeds of a commercial district about to bloom. Saloons soon opened, carpenters built homes, and butchers and shoemakers followed. With Manteno connected to markets to the north and south, business boomed.

The railroad's imprint on Manteno remains a century and a half later. Not just the tracks that slice through the middle of town, but the layout of the original streets mirror the track's northeast path through town, as do nearby major highways such as US Route 45, Illinois Route 50, and Interstate 57.

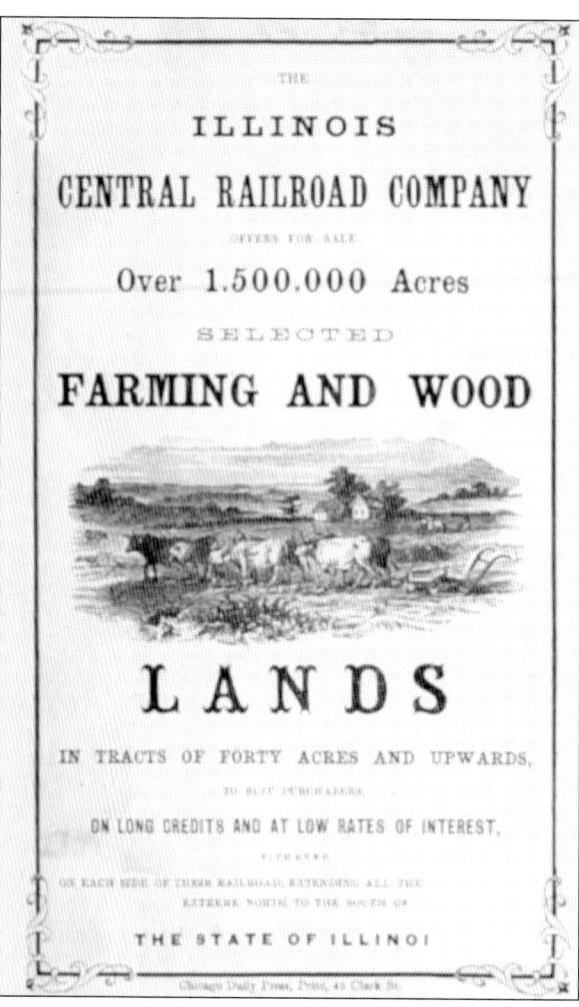

After Congress granted 2.6 million acres to Illinois in 1850 to construct a railroad, the state chartered the Illinois Central Railroad Company to fulfill the goal. With that, colonization of land along newly-laid tracks became a matter of strategy. This image shows one of the tools meant to entice people to buy land and "tame" the prairie. Other posters stated, "Men with families preferred." Attracting those who would settle down was the goal. (Courtesy of KCMPA.)

When Kankakee County was formed in 1853, it consisted of six townships, as shown here. It took only two years for Manteno to outgrow Rockville Township; it was formed in 1855 and consists of 36 square miles, carved out of the eastern portion of what was initially Rockville. By 1877, Kankakee County was divided into 17 townships, the layout that exists today. (Courtesy of Jack Klasey.)

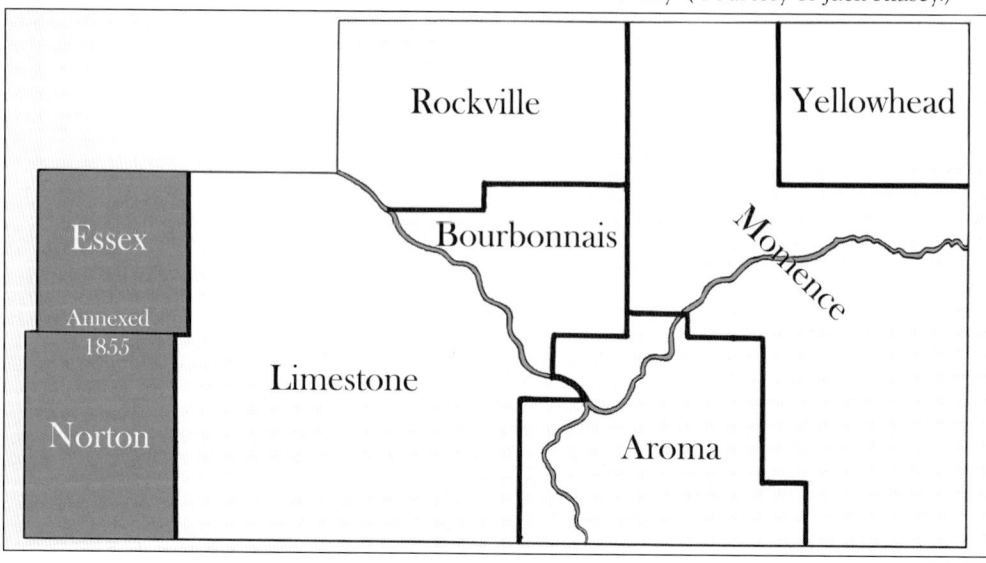

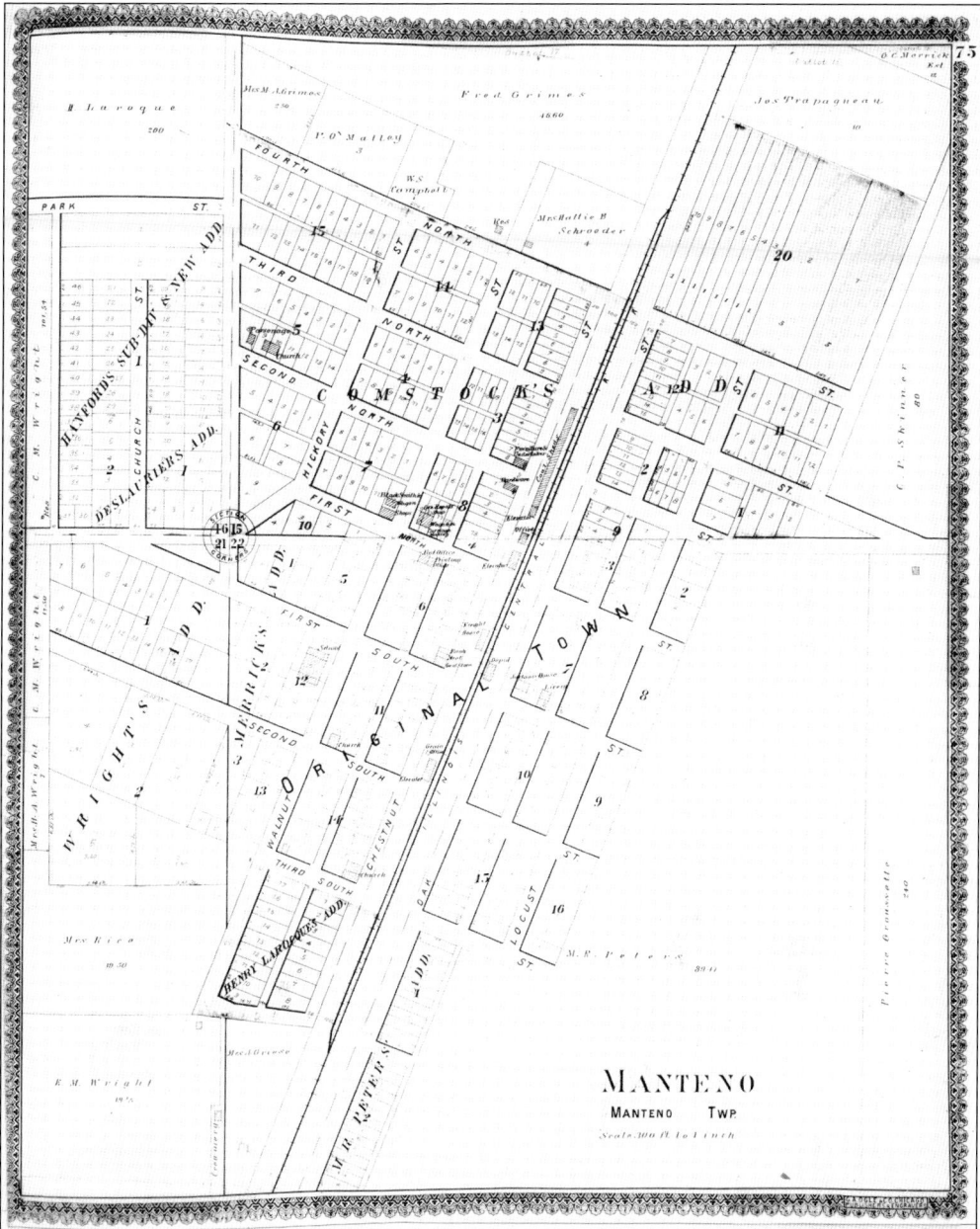

David Neal, an original director with ICRR, devised a naming convention, called the Neal Plan, whereby east-west streets were numbered and radiated out from the depot. The east-west streets directly north and south of the depot became First North Street and First South Street; two blocks north and south of the depot became Second North Street and Second South Street, and so on. Although the numbered streets to the north of the depot have retained their numbering system, streets to the south have changed. First South was renamed Division, Second South became Adams, Third South became Baker, and Fourth South became Cook. North-south streets, however, are still mostly unchanged from the Neal Plan and are named for trees. Chestnut ran along the tracks' west side (it was renamed Main Street soon after 1946); to the west of the tracks are Walnut, Hickory, Maple, and Poplar; to the east are Oak, Locust, and Birch. (Courtesy of MHSMRM.)

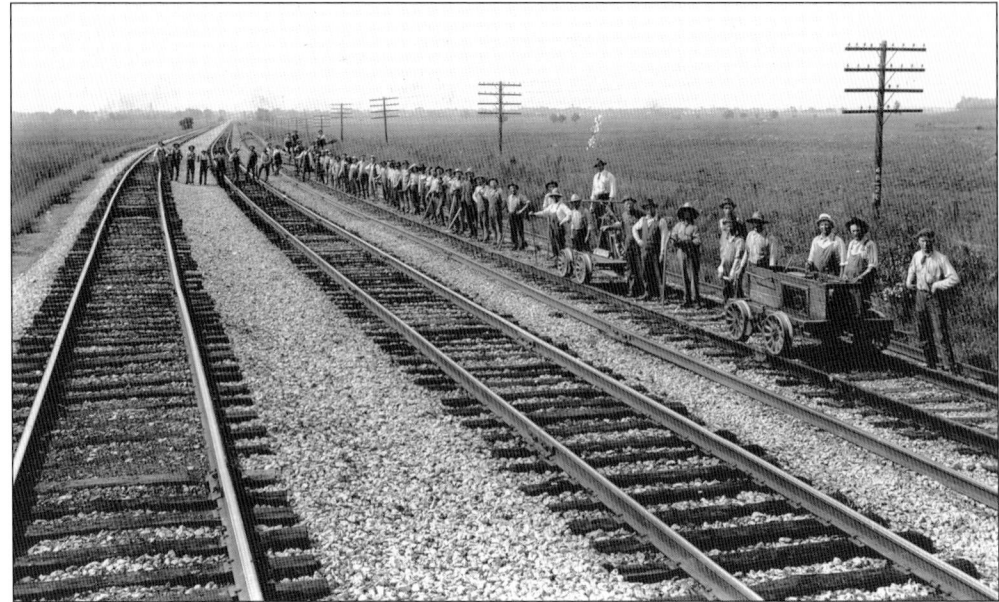

The line from Chicago to Kankakee was completed by 1853, but it was not until December 1854 that the line to Illinois's southern tip (Cairo) was finished. Later extensions branched west to St. Louis and south to New Orleans, linking markets from the Great Lakes to the Mississippi and the Gulf of Mexico. Construction crews such as the one pictured here were drawn to the area by advertisements; foreign-language newspapers were utilized in order to attract immigrants. Many stayed on at settlements along the lines they helped to build. (Courtesy of Edward Chipman Public Library.)

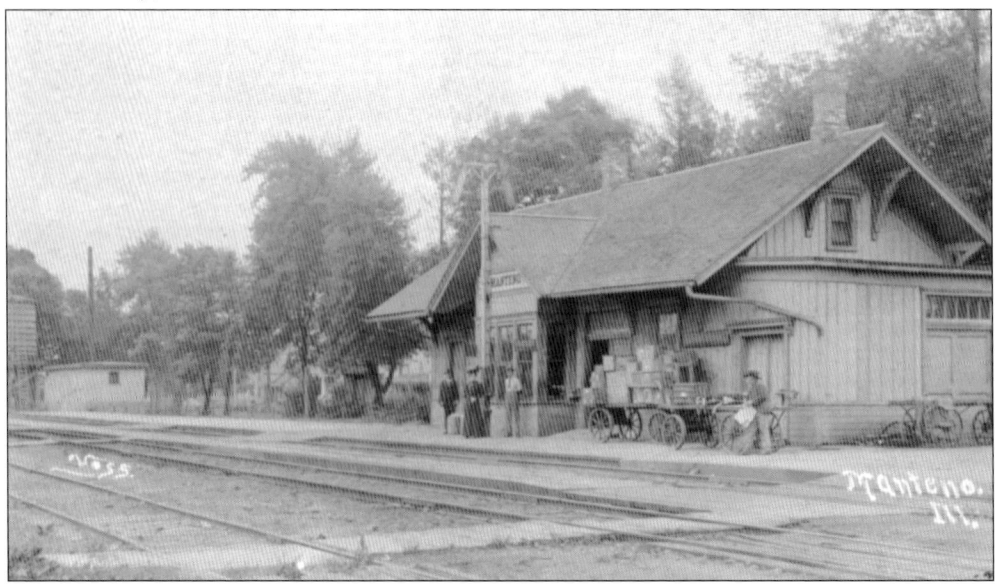

The ICRR depot, east of the tracks between Division and First Streets, was the nucleus of Manteno Depot when the rail line opened in 1853. This image shows rail passengers waiting on the platform and the large service door (far right) three feet above ground level, where items that arrived by train could be loaded onto buggies for delivery to businesses. This depot would later be lifted and rolled north when the interurban trolley line was built. (Courtesy of KCMPA.)

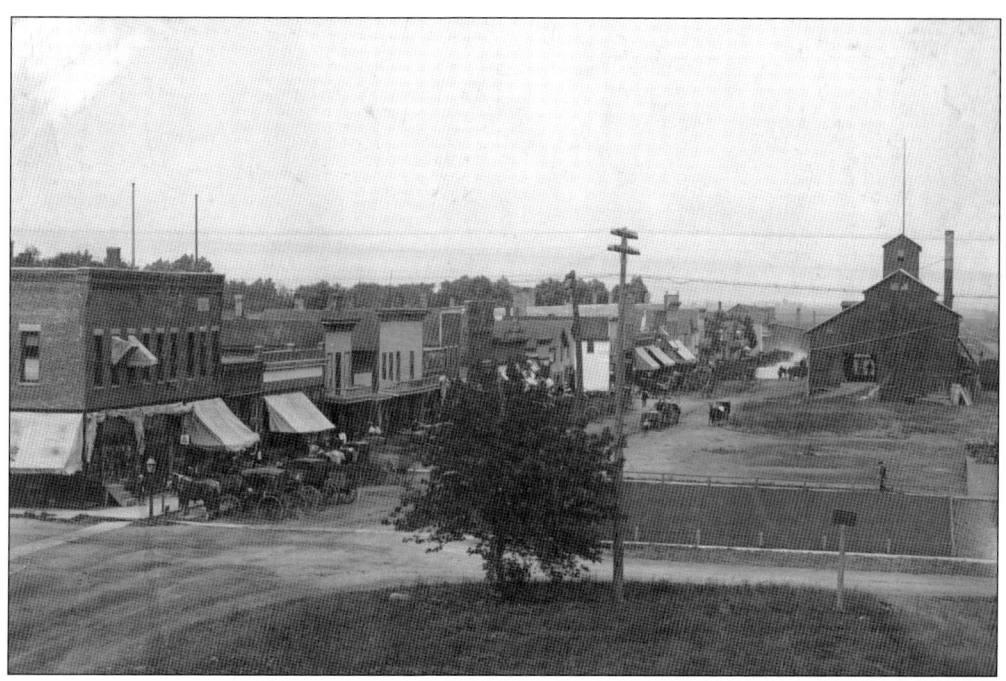

There are no automobiles in this image of Main Street, which looks north from the Carrington, Hannah and Co. grain elevator (built in 1897, it was later bought by West Bros.). The bell logo outside the Wright building indicates the presence of Central Union Telephone Co.; it opened in Manteno in 1902, training four women as switchboard operators. In the distance, north of town, no brickyard exists. This image is dated about 1903–1904. The animal pen in the right foreground is empty, but ICRR stockyards were normally filled. Pens on Main Street helped residents abide by village laws, which pronounced that "mules, sheep and hogs are not commoners . . . and not allowed to run at large." (Courtesy of MHSMRM.)

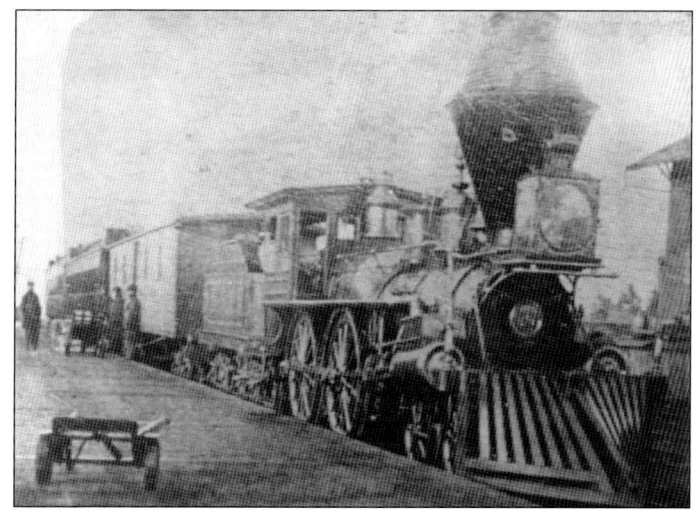

This 1868 photograph shows the Illinois Central locomotive and cars of the "Kankakee Accommodation," a train that ran between Chicago and Kankakee and stopped at Manteno. Before Kankakee became the county seat in 1853, the area was known simply as Kankakee Depot. Similar to Manteno Depot, there was little located near the spot before Illinois Central built a station. (Courtesy of KCMPA.)

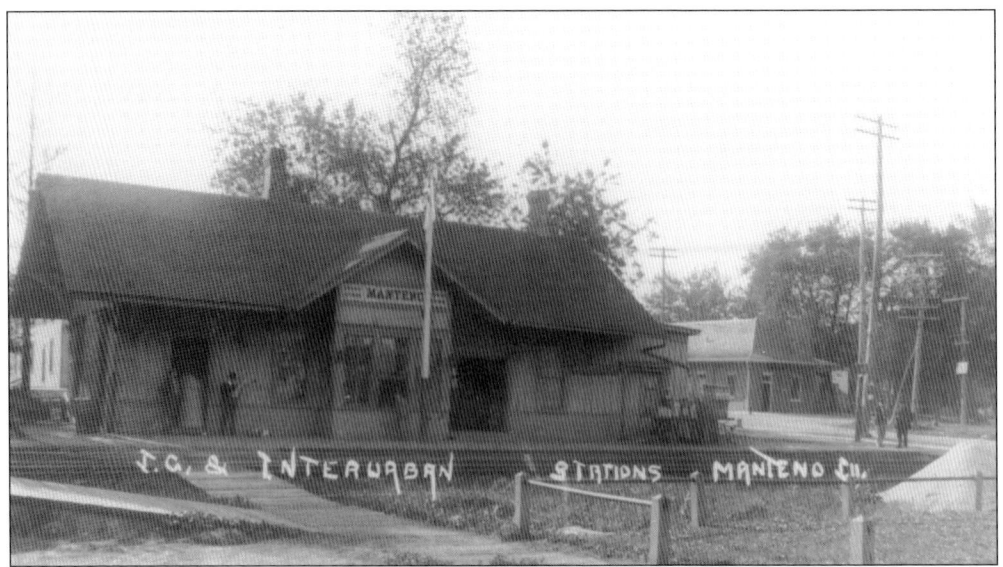

Nine thousand miles of electric interurban lines were built in the nation from 1901 to 1908; two-thirds were in six states, and Illinois was ranked fourth. The most important lines were within 50–60 miles of large cities, including the one run by Chicago & Southern Traction between Seventy-Ninth Street in Chicago and Kankakee. Pictured is Manteno's interurban trolley station (in the background) across the street from the ICRR depot. (Courtesy of MHSMRM.)

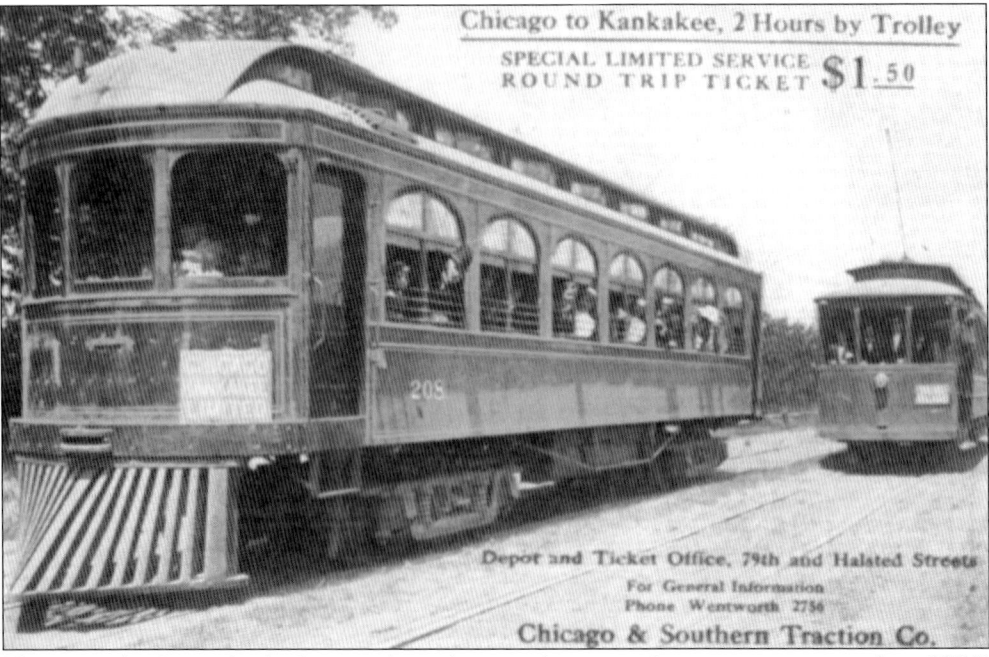

The interurban's novelty, higher speeds, and greater frequency drew passengers away from ICRR passenger trains, which decreased revenue. However, the interurban's days were numbered by output from Detroit—the nation's motor vehicle registrations rose from 3 million in 1916 to 19 million in 1926. Interurban service to Manteno ended in spring 1927. ICRR passenger service would last until 1969, when Train No. 28, which stopped on Sunday mornings to discharge visitors to the state hospital, was eliminated. (Courtesy of Kankakee Railroad Museum.)

Three

Farms and Related Businesses

Two structures have dominated Manteno's skyline for more than a hundred years: the Farmer's Elevator to the north and St. Joseph Catholic Church to the south. Both are on Main Street, and both are along the railroad tracks. Together, they are bookends for the town's story—from its strong agrarian roots to its religious history.

Some of Manteno's first farms were owned by Chauncey Brockway, Daniel Beedy, Cleophus Guimond, Smith Payne, brothers Milo and Oliver Barnard, Giles Grimes, Alexander Viall, and the Gilkersons (Robert, Agnes, David, Parne, and Luther)—the list goes on. The chance to buy 40 acres of fertile land lured many a farmer, and businesses sprung up to meet their needs. Perhaps most important was a cooperative formed to help secure the most money for grain from the market, formed in 1856 by Zalmon P. Hanford. In 1857, Hanford built a grain elevator on Chestnut Street (Main Street), which later became Euziere's Elevator. Just a few decades after its incorporation as a village, Manteno became known as the "grain center of the state." It was also the site of one of the most extensive dairy farms in Illinois, that of Elnathan Wright, whose first endeavor was raising sheep when he arrived in 1859.

Farming's landscape has drastically changed from the 19th to the 21st century. Illinois is one of seven Midwestern states with some of the most fertile soil in the world; even so, farming has declined. Younger generations have been moving away from farms for decades, encouraged by their families to pursue advanced education or jobs that pay better, and some were driven away by other factors. Technology has brought about higher production with fewer people, so that seeking employment off the farm was a means of survival. From 1933 to 2015, the percentage of America's population engaged in agriculture dropped from 25 to just 2. This means that two percent of Americans are feeding the nation, a fact overlooked in the grand scheme of national priorities. Honoring the forerunners of those two percent provides a view into today's agricultural industry, one whose average worker's age was 57 in 2018.

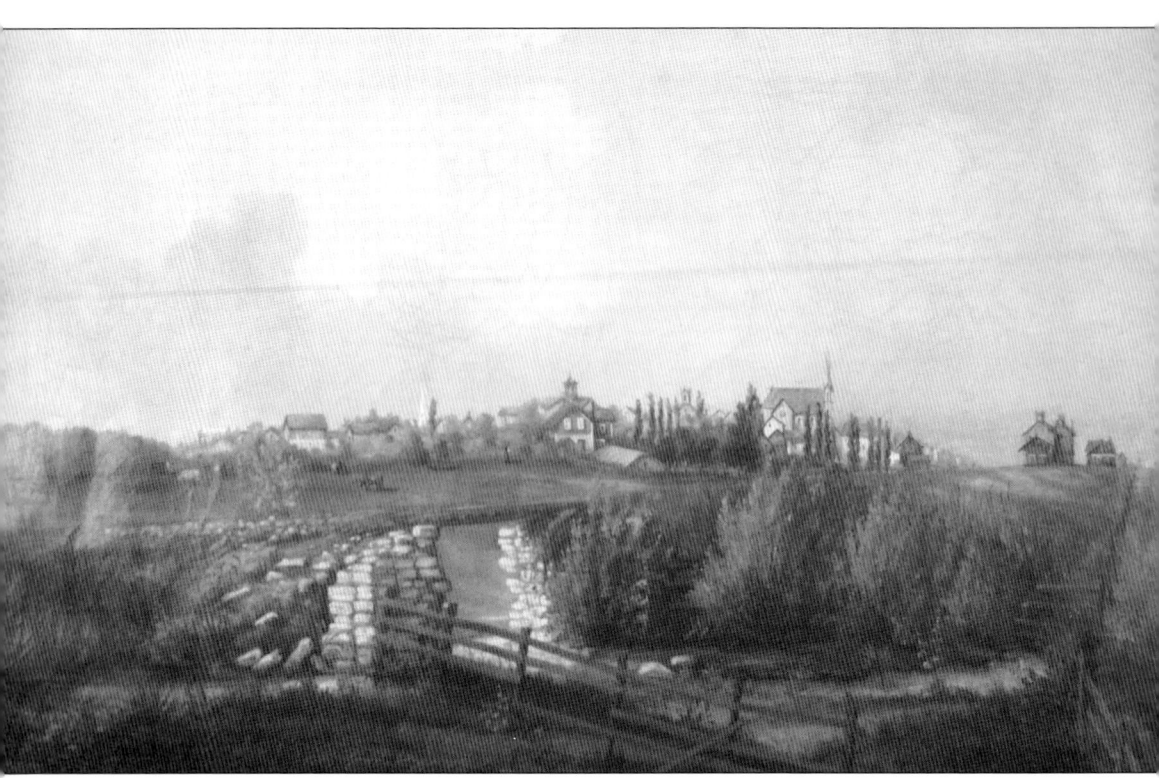

Artist H. Fevrier from Lyon, France, was cousin to Leon Euziere and captured the village in this oil painting in 1877. The Wright creamery is visible with the schoolhouse's roofline and large cupola directly behind it. Also visible are Manteno's first three churches (the Methodist's white spire, the Presbyterian's bell tower, and the Catholic's two tall spires), and Euziere Elevator along railroad tracks that continue south out of town. When the last Euziere died in 1967, the family graciously let the village keep this portrait. At that time, Mayor Leo Hassett declared it "the only known panoramic picture of our community in its early years." It was refurbished by Euziere descendants in 1992 and formally donated to the Manteno Historical Society. (Courtesy of MHSMRM.)

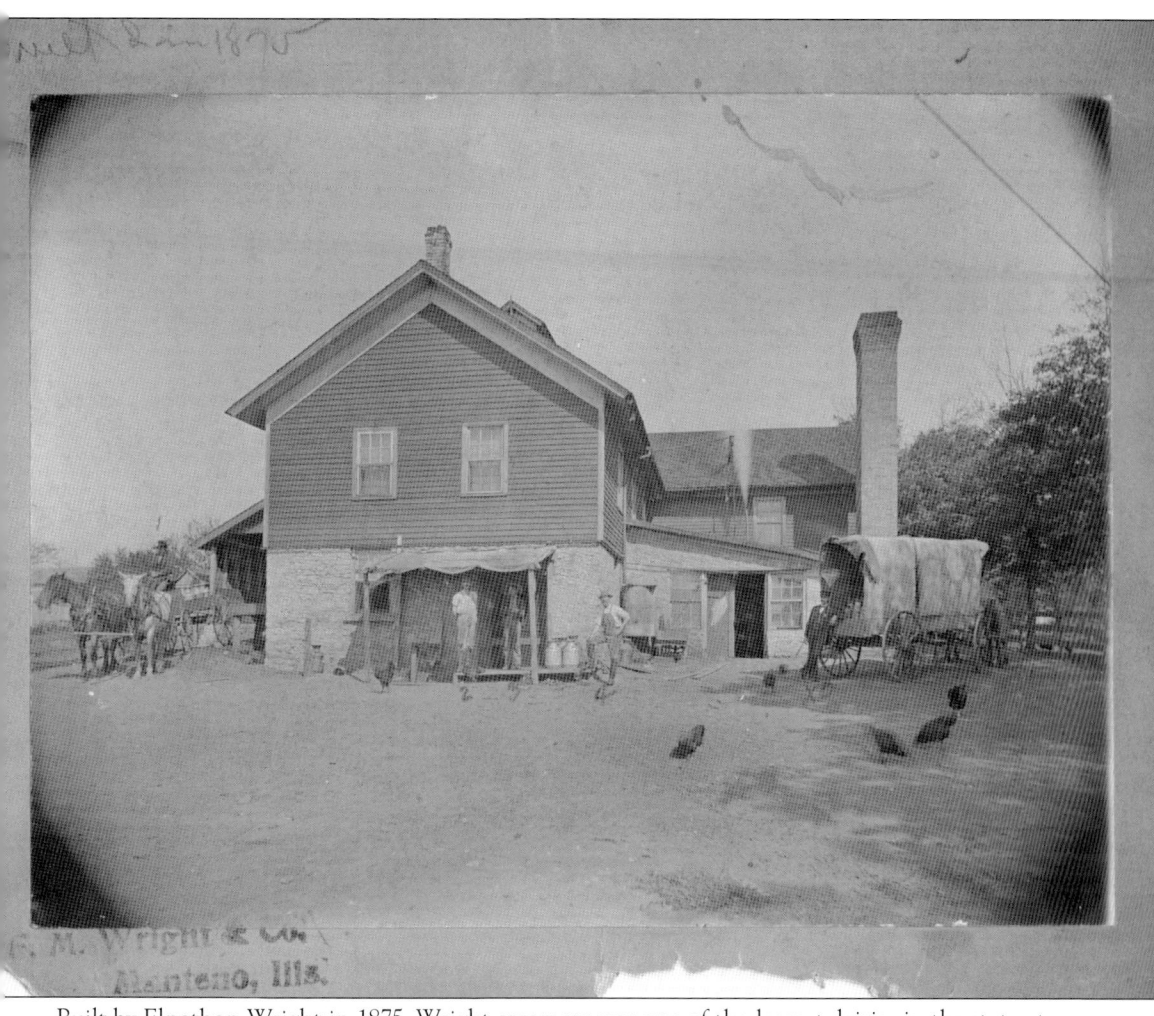

Built by Elnathan Wright in 1875, Wright creamery was one of the largest dairies in the state at one time. This c. 1885 image shows its south entrance into the ground floor factory (porch with overhang) and separate entry at right into a boiler room leading to an east interior door to the factory floor. Barely visible above the roof's peak is a large cupola, removed in later years. The creamery sat at the end of a gravel lane just beyond Manteno's southern edge; that boundary became Fourth South Street, later Cook Street. This structure's stone first story gave way to an upper story built of timber, painted red, which provided housing for the owner's family or workers—at least one worker's baby was born in the upstairs flat, Irene Minnich in 1904. Pictured on the buggy at left is Henry Bisping. Standing near the doorway are, from left to right, James Kisner, ? Croxen, and Daniel Simms. By the wagon at right is Frank M. Wright, son of Elnathan. (Courtesy of MHSMRM.)

Homer and Blanche (Keller) Bowman moved into the upstairs flat of the closed Wright/Minnich creamery in 1936 with their children Russell, Vera, and Mildred. Russell married Nedine Lemenager, and they raised five children there. This 1974 image shows the ground-floor addition on the south, built when the creamery was in operation; a sunporch was later built atop this addition. The Bowmans were the last to live in the structure before it was razed in 1975 to make way for Wright Estates. (Author's collection.)

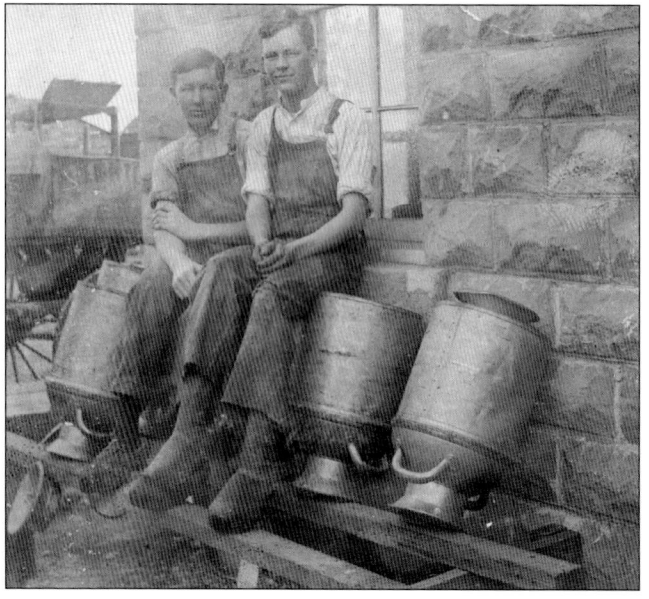

Henry Wright (left) and Harry Minnich Sr. are pictured in 1902 outside Wright creamery; behind them is the wall of the ground floor addition, built of 10-by-4-inch smooth stones, a material that was easier to keep clean than the rough stone of the original structure. Both men are wearing wooden shoes (from the Sears catalog) to keep their feet dry. Henry managed dairy operations by this time; in 1883, his father, Elnathan, drowned in Rock Creek, the south branch of which ran through the farm. (Courtesy of Martha Minnich O'Connor.)

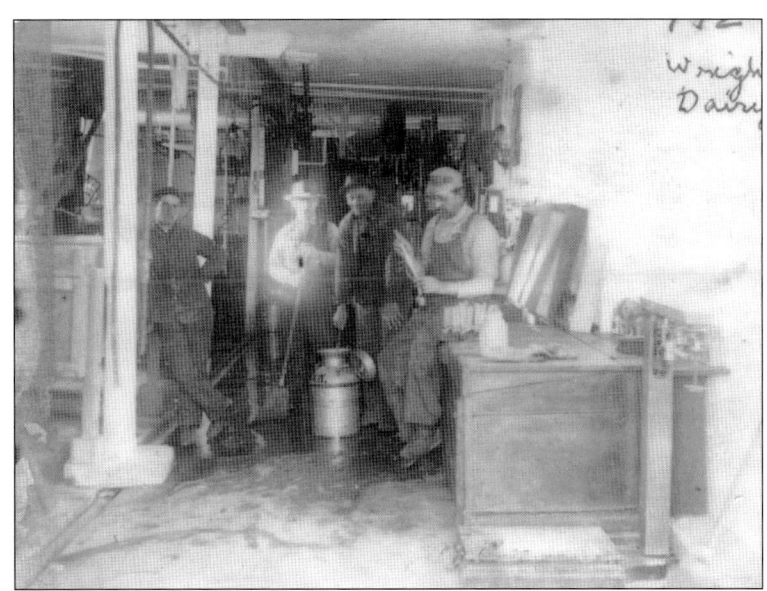

This 1929 image of the Wright/Minnich creamery shows how the factory floor was pitched toward a drain. The milk can was the type used to collect from local farmers, a practice started by Elnathan Wright that led to the creamery growing into one of the largest dairy operations in the state. (Courtesy of Martha Minnich O'Connor)

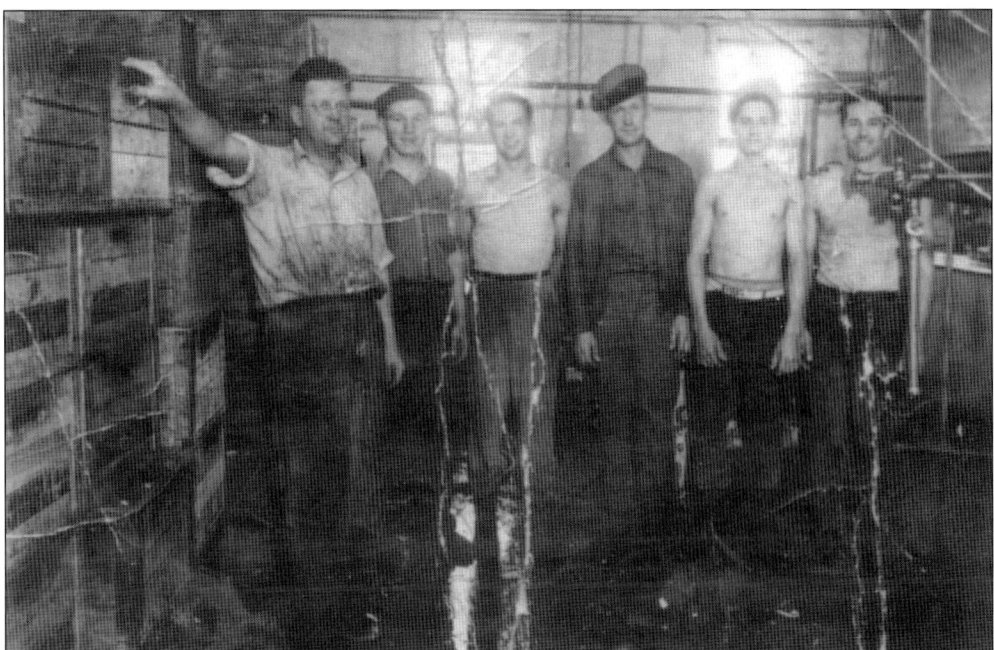

Phares S. Minnich and son Harry (Sr.) began P.S. Minnich & Son Dairy in 1925, utilizing the old Wright creamery. Around 1930, they raised a building at 389 South Locust and opened a lunch counter and gas station and later moved the dairy operation there. This image of Minnich Dairy on Locust includes Harry Minnich Sr. (far left) and Roy Keller (far right); the others are unidentified, though the man wearing a hat was likely a dairy truck driver. Minnich Dairy closed in 1948. (Courtesy of Martha Minnich O'Connor.)

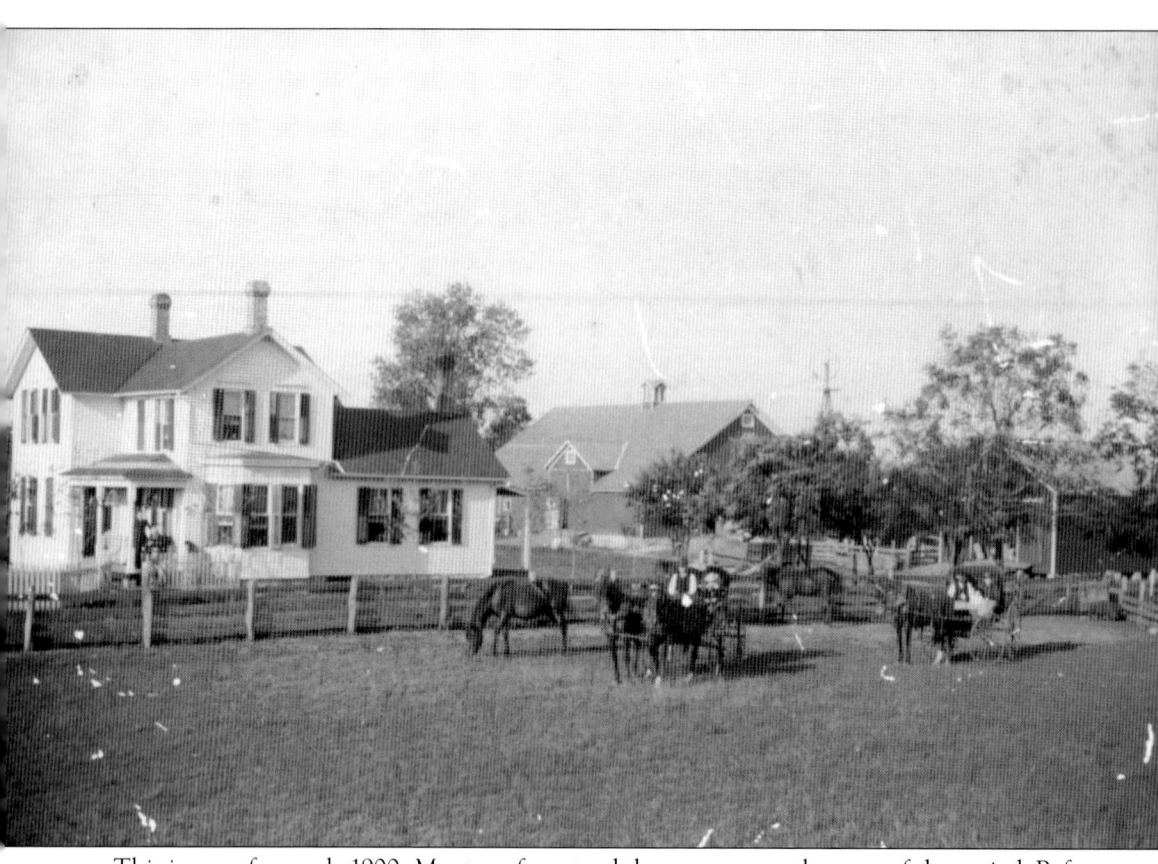

This image of an early 1900s Manteno farmstead shows common elements of the period. Before steam engines or electricity, people looked to wind for power. The fan-type windmill in the distance, positioned over a well, pumped water for the farm. Though windmills predate modern civilization, America's first commercially successful windmill was invented in the 1850s. Called "self-governing," it could swivel to face the changing wind on its own. Though New Englander Daniel Halladay invented it, demand dictated that he relocate his company to the Midwest; he landed in Batavia, a Chicago suburb. Chicago would also be the site of the future Aermotor, a company still in operation. The wooden post-and-rail fence is indicative of the type of livestock being raised; note the hogs grazing at far right. Though barbed wire was invented in DeKalb (also near Chicago), it could contain cattle, not hogs. This farmstead is believed to have been part of the holdings of George Day or the William Curl family, located northwest of Manteno; those pictured are unidentified. (Courtesy of MHSMRM.)

John Weber and Philippina Rulf were both born in Germany and came to the area as children with their parents. They married in 1870 and had 12 children (10 lived to adulthood). This 1893 image shows the farm where the family lived at the time, northeast of town (the home still stands). From left to right are Philip (born in this house in 1888), Charlotte, Kate, Helena, Wilhelmena, Philippina, Elizabeth, and John. The family later settled on a farm southwest of the village. After John died in 1913, Philippina continued farming with the help of her children. (Courtesy of Franklin Weber.)

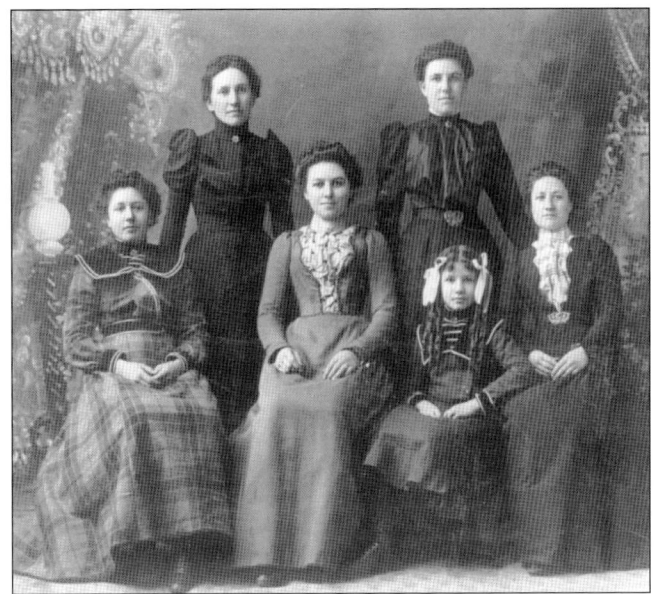

Pictured around 1899 are the six daughters of John and Philippina Weber. There were also six sons, of whom four grew to adulthood. From left to right are (first row) Charlotte, Wilhelmena, Helena, and Elizabeth; (second row) Rose and Kathryn. Their clothing reflects the period—skirts were bell-shaped (hugging the waist and flaring at the bottom), corsets and petticoats were undergarments of the day, and on their feet are shoes with thick heels and pointed toes that laced and rose above the ankle. (Courtesy of Franklin Weber.)

27

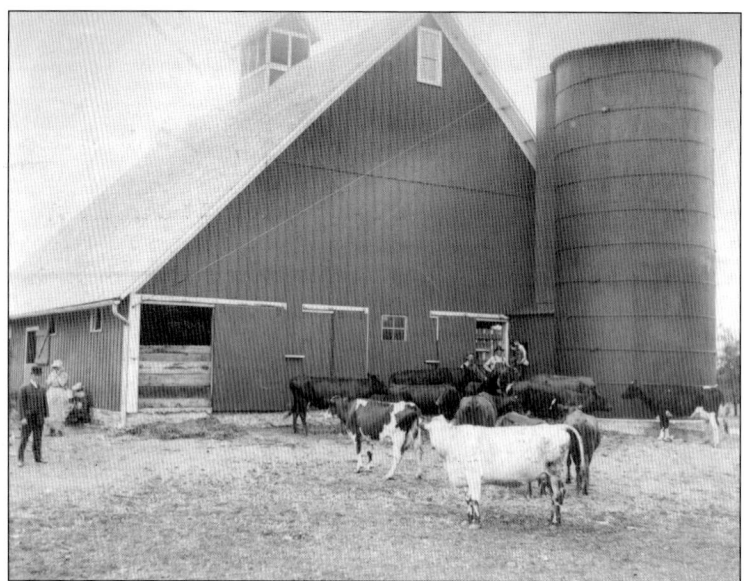

This farm northwest of town in Section 9 was operated by Charles and Blanche Barnes. The ages of the subjects in this photograph indicate it was taken about 1918. From left to right are Phillip Paquette (a visitor to the farm), Blanche Barnes, Charles Barnes, unidentified, and Willis Barnes (child). (Courtesy of MHSMRM.)

Though Manteno Township was carved out of Rockville Township in 1855, Rockville farms and families are very much part of Manteno's fabric—their children attend the consolidated school district, and many attend village churches. This c. 1889 image's inscription describes it as "The Edna Mann Farm" in Rockville; from left to right are Edith Bromley (who married John Marr), Elsie Bromley, Weltha (Farmer) Bromley, and Harvey Bromley. From the Bromley line comes Manteno's Marrs, Shipps, and Shears. (Courtesy of MHSMRM.)

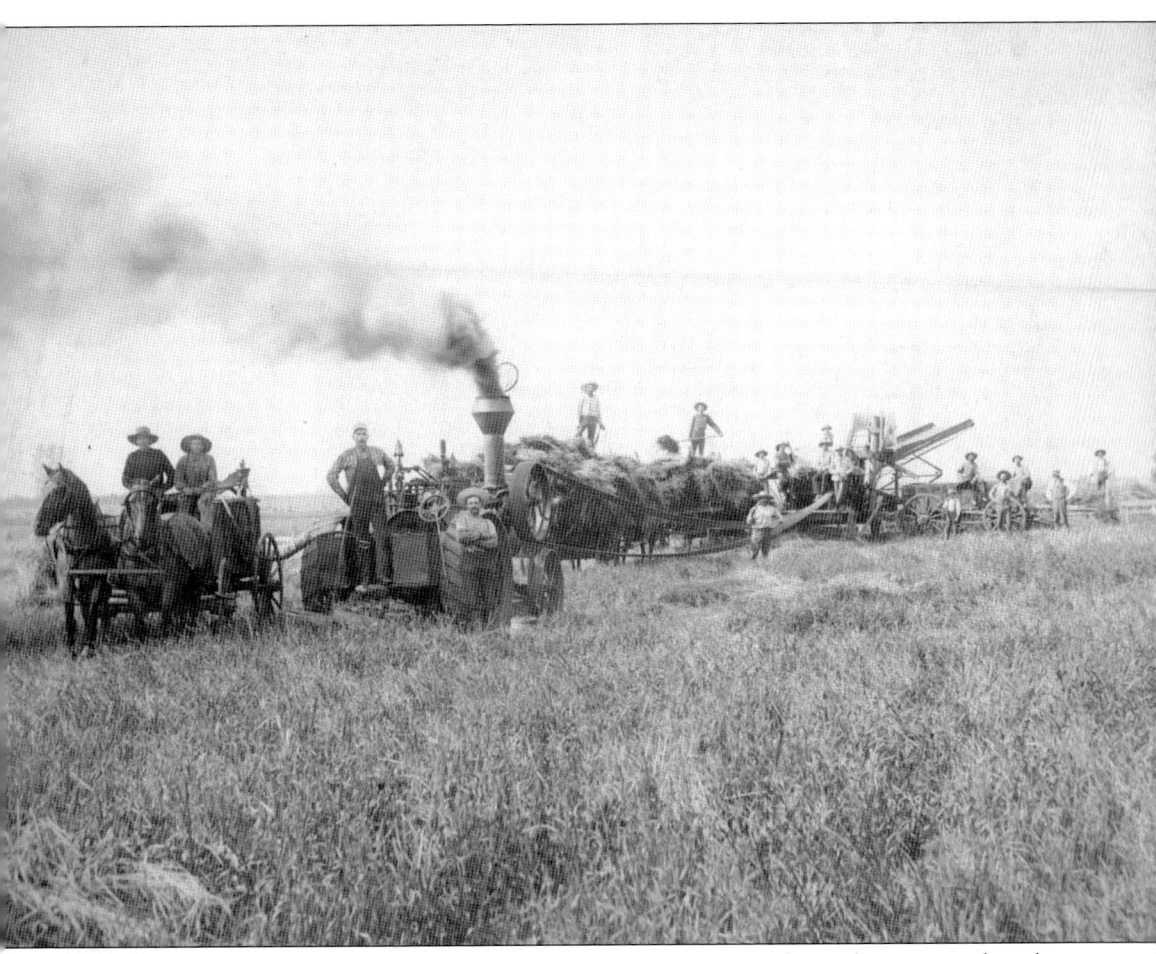

Handling grain used to require teams of workers such as this one pictured in 1893 gathered to perform threshing (separation of grain from the husk or hull). In the front is a steam engine, which powered a conveyor belt that ran the threshing mill. Standing on the engine is Ed Payne, whose father, Smith Payne, came to Manteno in 1855 and resided on a farm northwest of the village for more than 40 years. The others are unidentified, but they were surely engaged in cutting, bundling, and hauling the grain to ready it for threshing; before the invention of the combine, these were separate steps. Farm families helping each other has moved beyond a requirement to a long-honored tradition. When a farmer is sick with cancer or undergoes surgery, colleagues tend the fields. One example among many occurred in 1965 when 20 farmers plowed and planted 126 acres in one day for their ill neighbor John Shear. (Courtesy of MHSMRM.)

After John Tritley bought 80 acres of land one mile east of town in 1866, his son-in-law Michael Lawrence moved his wife, Margaret (Tritley), and six children to the farm. Michael purchased Tritley's 80 acres plus 80 additional acres adjacent to the south. Though Michael's son Vernon joined him in farming, his son George would go on to become a world-famous photographer. Pictured in 1901 is the Lawrence family; from left to right are (seated) Emma, Michael, Margaret, Nell, and Clara; (standing) Laura, Vernon, and George. (Courtesy of MHSMRM.)

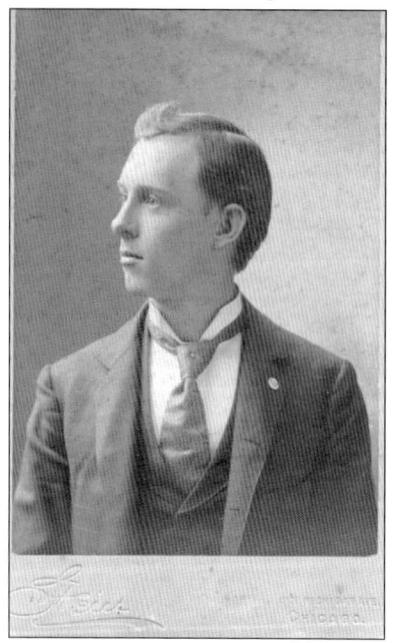

George R. Lawrence, pictured here, attained an eighth-grade education in Manteno, then went on to become a "technological genius." In 1888, at age 20, Lawrence moved to Chicago, where he invented the largest camera in the world and captured the Alton Limited passenger train with one exposure. That image earned him the Grand Prize of the World for Photographic Excellence at the 1900 Paris Exposition, but only after a judge traveled to Chicago to inspect Lawrence's camera. As the 20th century dawned, Lawrence stood alone—no other kite or balloon photographer produced images like his. (Courtesy of MHSMRM.)

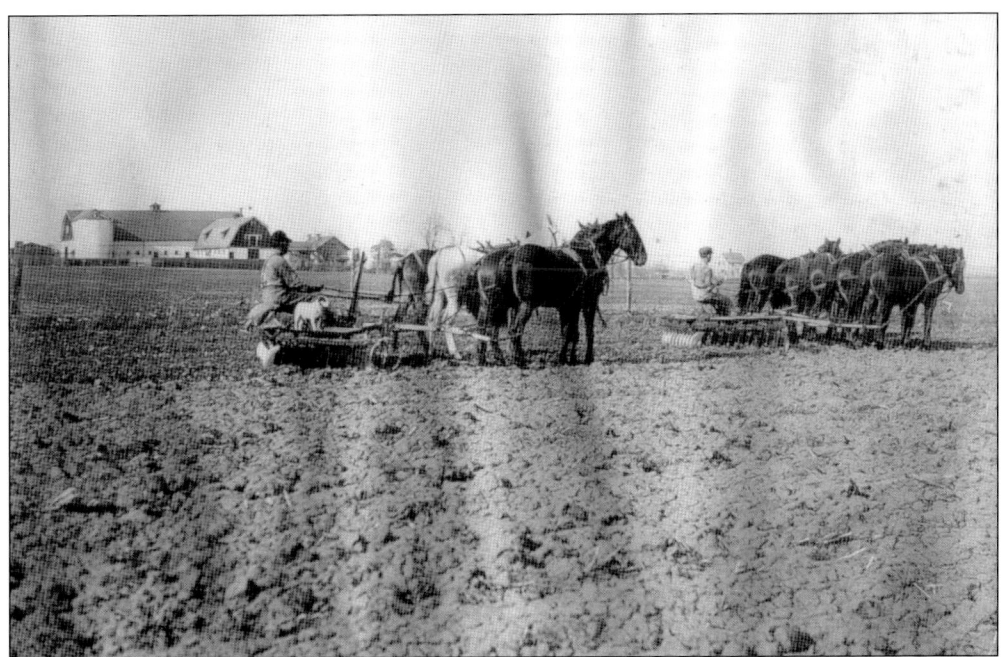
Luther W. Smith married Carrie Wright in 1894, and they moved to a farm west of the village originally owned by Carrie's father, Elnathan Wright. This image shows Smith and a farmhand readying the soil for planting by breaking up the surface with horse-drawn disc harrows. The Smiths' L-shaped barn and houses are in the background. (Courtesy of Bryan Spangler.)

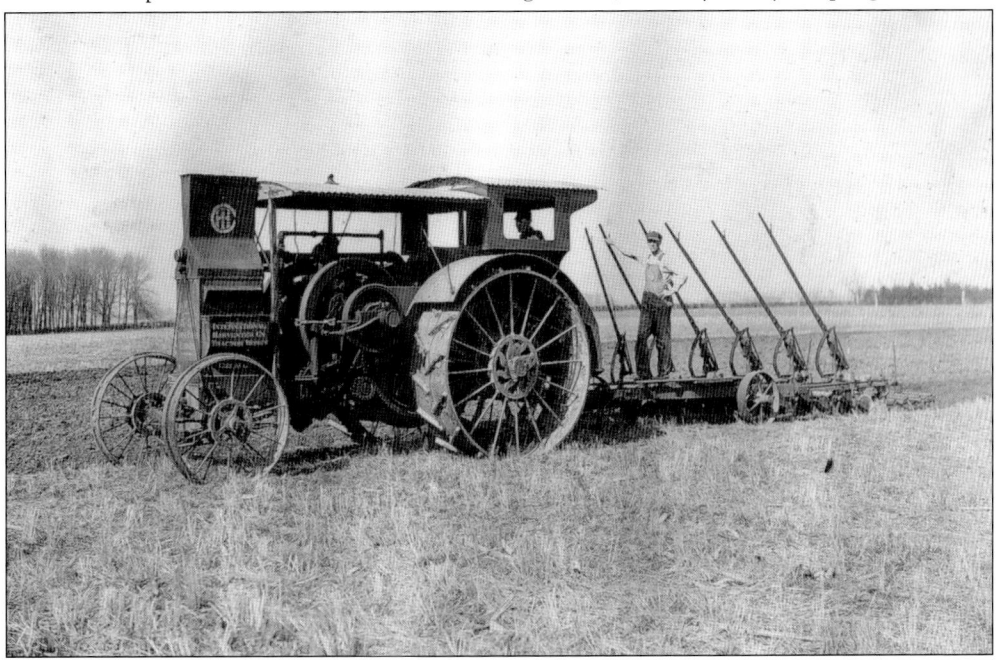
The first gasoline tractors were sold in 1902, had large steel wheels, weighed about 20,000 pounds, and replaced horses for plowing fields. This tractor was made by International Harvester, one of three large manufacturers besides Hart-Parr and Rumely that made tractors. (Courtesy of Bryan Spangler.)

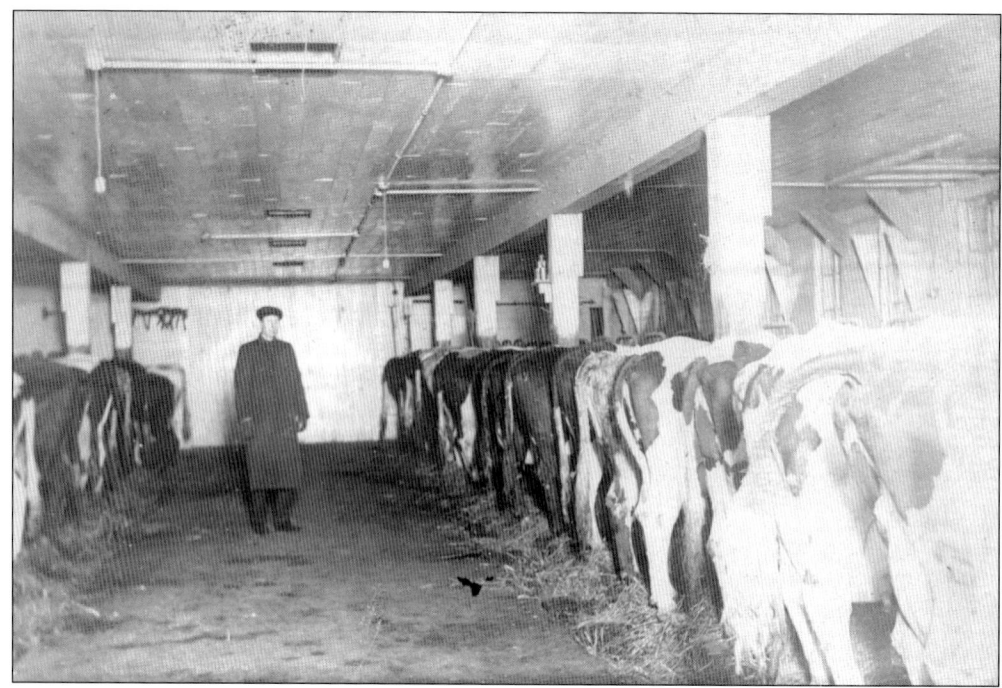

Dairy farms such as Luther Smith's (pictured here) were crucial to area creameries. This farm has been known by two names: a 1914 issue of the *Cement Era* called it Highland Farm, and by 1941, it was referred to as Blue Ridge Farm (William O'Toole owned it after Smith until 1941). The *Cement Era* described Smith's cow barn as "magnificent," with one arm of the L-shaped barn laid on the ground, the other a suspended floor with the dairy underneath. Smith extolled concrete's advantages (easily maintained) and used it extensively. (Courtesy of Martha Minnich O'Connor.)

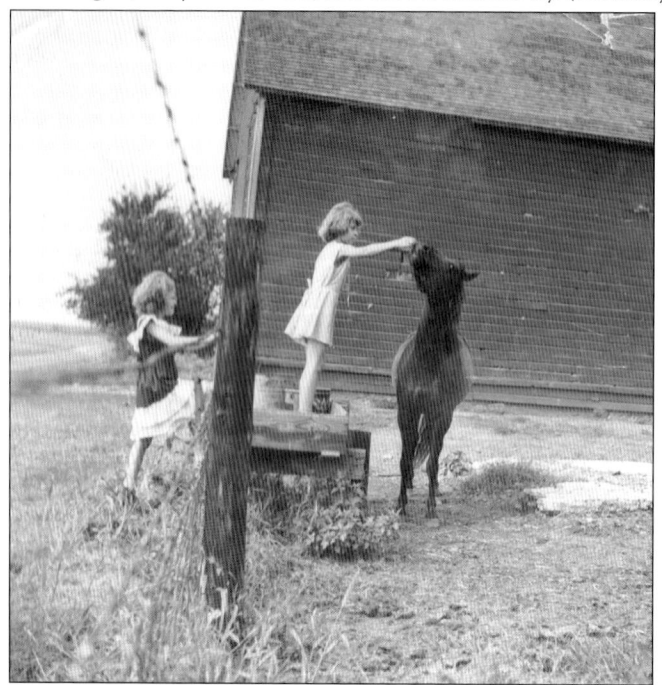

What was once a necessity became a luxury later in the 20th century. Pictured in 1947 are children about to partake of one of the perks of farm living: horseback riding. Pictured are Pat Estes (left) and Joy Stauffenberg with Flicka the pony. The location was the Donald and Barbara (Babb) Stauffenberg farm. (Courtesy of Susan Stauffenberg LaMore.)

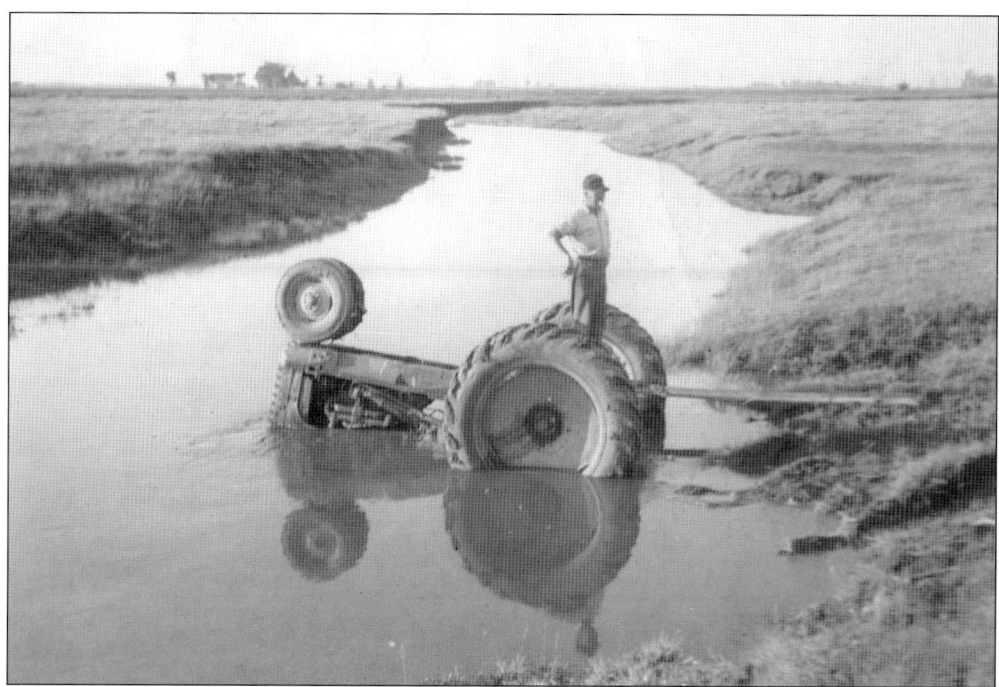

Before Henry Ford made automobiles, he produced a successful small tractor with steel wheels. Rubber tires for tractors became available in 1932, and development of diesel engines in the mid-1930s meant affordable fuel. Despite the Depression, tractor sales increased from the mid-1930s and slowed only due to World War II when steel and rubber were in limited supply. Despite improvements, the tractor could still cause headaches, as exhibited in this image from S-Creek Farm. (Courtesy of Susan Stauffenberg LaMore.)

Farming is a family affair. Though men's names were usually attached to farm operations, women have plowed the land as well, as shown in this c. 1980 photograph of Anitra "Ann" (Hertz) Spangler on the family farm. (Courtesy of Bryan Spangler.)

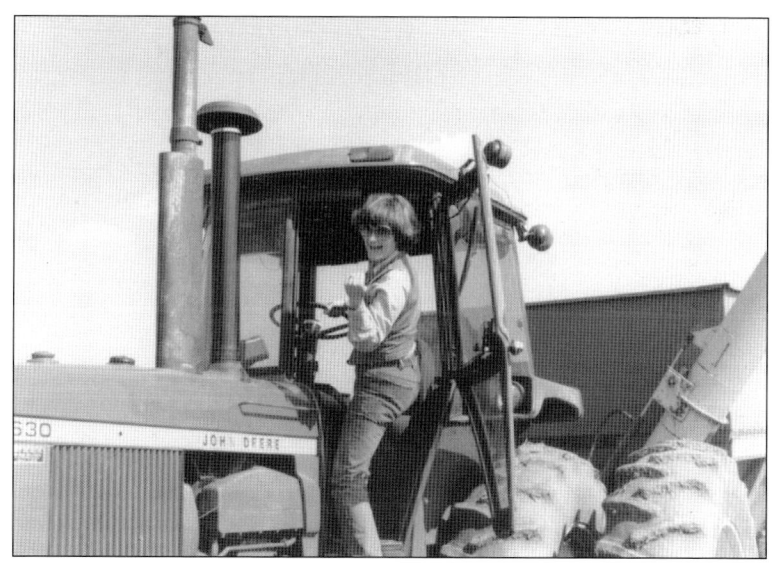

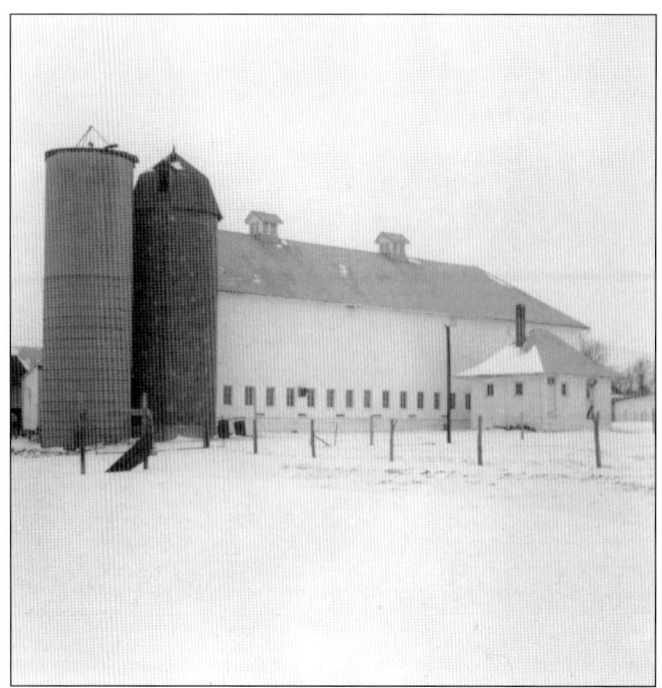

This dairy barn has cupolas built into the roof for ventilation (an airtight barn results in a buildup of condensation during winter from cow breath). The small one-story building attached to the barn is the milk house, which was used to collect and store milk; having this separate from the barn protects milk from smells and dust. The two cement silos stored silage (cattle feed). This farm, formerly managed by the Wrights, was run by Gary Provost in the 1960s and 1970s; those who lived on South Walnut near Cook Street remember cows getting loose and meandering past. (Courtesy of MHSMRM.)

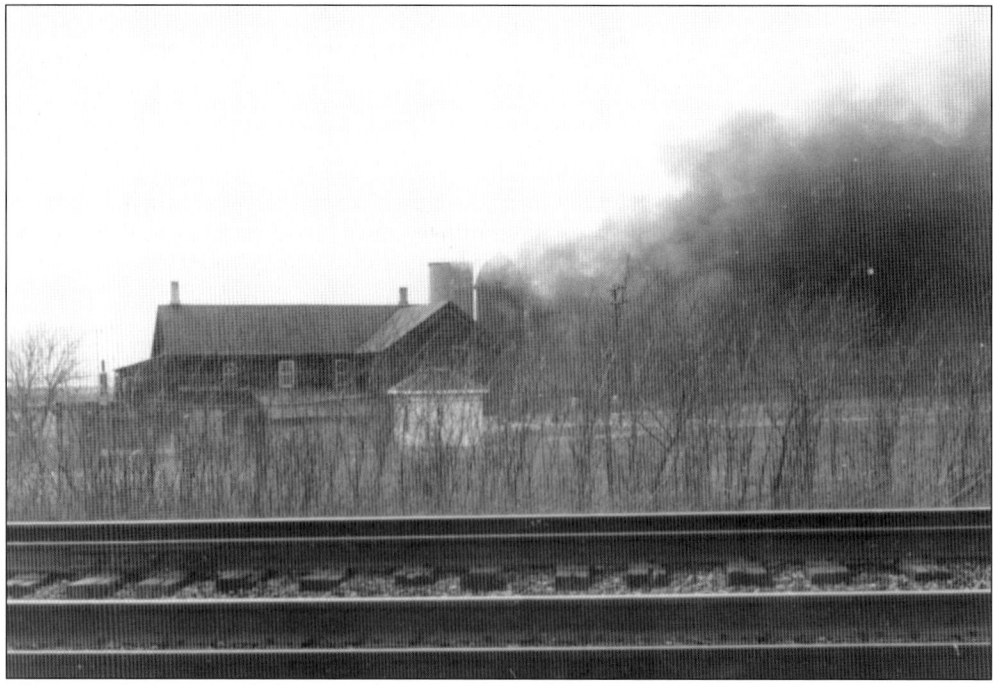

The once-thriving Wright/Provost dairy farm burned down on April 11, 1971. Frightened cattle ran out of the barn and back in again; most perished. This image is from the east, atop the railroad tracks. Two silos on the other side of the old creamery are visible through the smoke, and the village's pumphouse (for the well dug in 1937) is the small white building between the creamery and tracks. The dairy farm was not rebuilt; the land was converted to cornfields and then Wright Estates. (Courtesy of Martha Minnich O'Connor.)

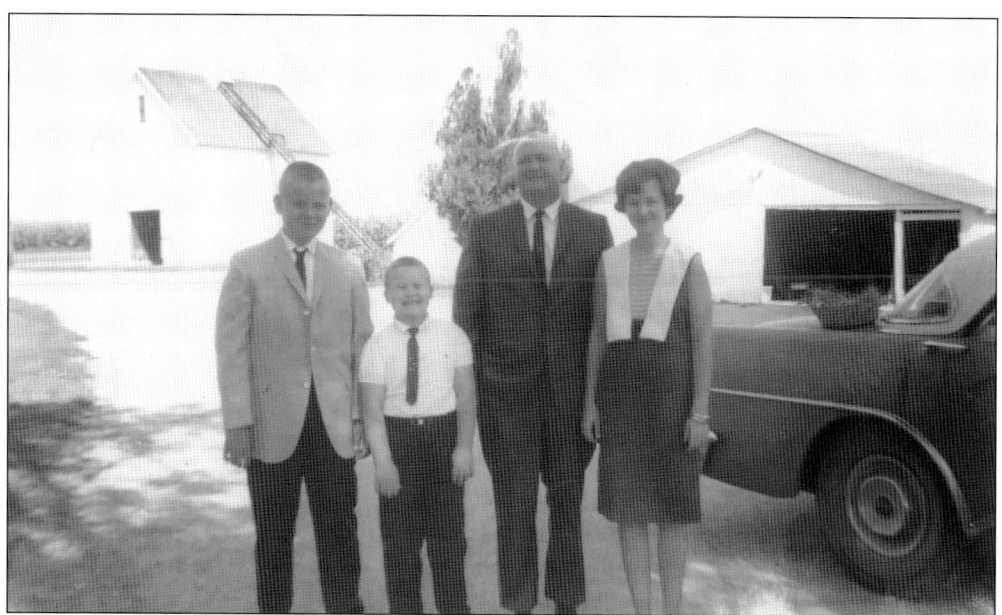

Pictured on the Mallaney farm southwest of town on Route 45 are Joseph "Joe" F. Mallaney and his children (from left to right) Mike, Patrick, and Jodi. The corn crib in the background had to be razed when the highway was widened. Joe F.'s parents, Joseph G. and Yvonne (Hughes) Mallaney, purchased the farmstead around 1917 and raised five children (one son and four daughters, including Patricia who became kindergarten teacher "Mrs. Layne"). The below image is Joe F.'s wife, Jacqulyn "Jackie" (Gerretse), posing around 2000 by the plaque awarded to the Mallaney family for second place in the 1940 Governor Henry Horner Farm Floral Contest. Horner, who resigned his 18-year judgeship with Cook County in 1932 to become governor, started this contest in 1933. It continued through the year after his death in 1940. The contest was designed to encourage farmers to enhance the beauty of the state by planting flowers along highways for enjoyment by travelers. Mallaney descendants continue to live in the original farmhouse (now enlarged)—Joe F.'s son Patrick runs an auto repair business on the property. (Both, courtesy of Patrick and Julia [Nelson] Mallaney.)

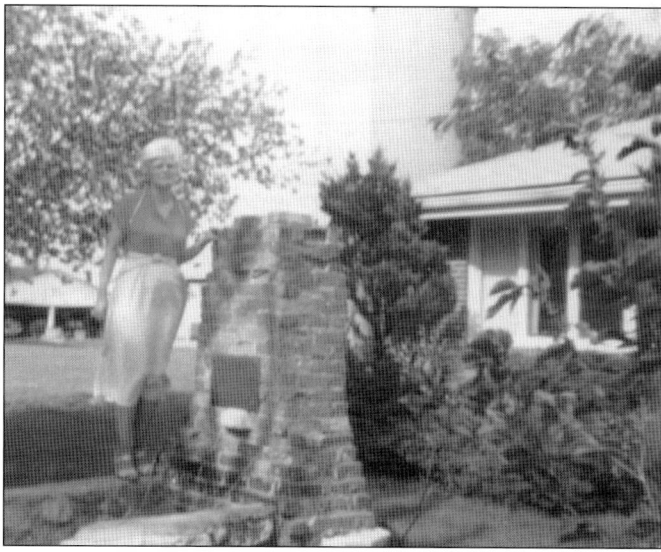

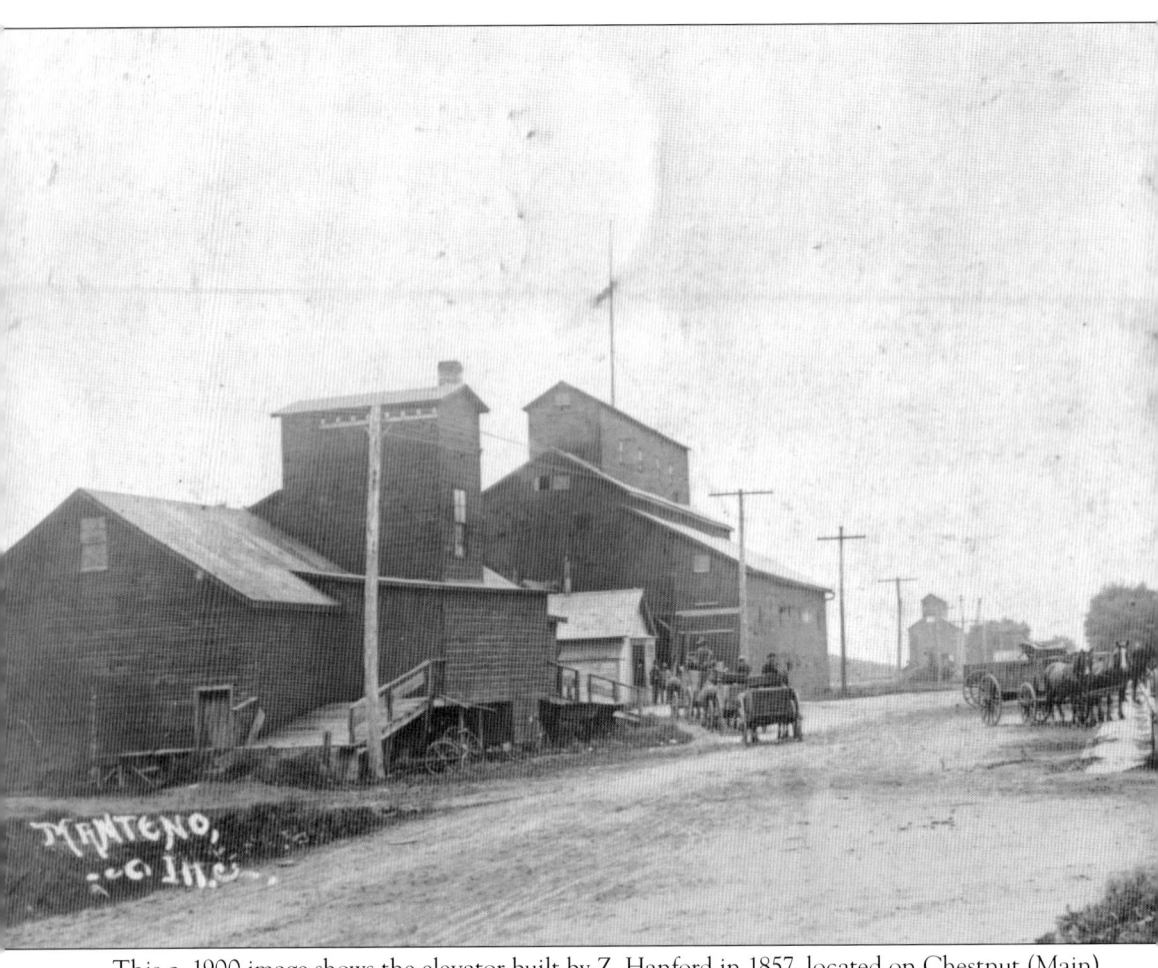

This c. 1900 image shows the elevator built by Z. Hanford in 1857, located on Chestnut (Main) Street along the west side of the railroad tracks. Farmers are lined up, waiting to conduct business. This was Hanford's Elevator until the 1860s. By 1866, the business was Lockie, Euziere & Co., run by Adam Lockie and Leon Euziere. After Lockie died in 1882, it became Euziere & Co. Elevator. In this photograph facing south, a second elevator is visible two blocks due south of Euziere's, built in 1897 by Carrington, Hannah & Co.; later known as West Bros. Euziere's storage shed (foreground, left) was dismantled in 1947, and Euziere's office (small white building between storage shed and elevator) was moved in 1964 to a site near Raymond Wyatt's trailer on the Phil Lamore farm. The enormous elevator was a landmark until the 1970s, when it was razed. (Courtesy of Farmers Elevator Co. of Manteno.)

Manteno got its third grain elevator in 1913, when the Farmers Elevator Company was formed with directors William Kimmelshue, Patrick Grant, Ed Payne, Fred Senesac, Alex Suprenant, William Stauffenberg, Treffle Soucie, William Salzman, and George Hatch. This frame structure was built and put into service in 1914. (Courtesy of Farmers Elevator Co. of Manteno.)

In May 1959, a fire destroyed the Farmers Elevator Co.'s original 1914 structure along with 12,000 bushels of grain stored in it. Reports say that spontaneous combustion started the fire. Since Farmers Elevator had acquired Euziere's old elevator in 1956, the company used it for storage until new construction began, as well as a facility it owned at Indian Oaks. (Courtesy of Farmers Elevator Co. of Manteno.)

Farmers Elevator Co. built a new 133-foot-high, 65,000-bushel capacity concrete elevator to replace the one that burned in 1959. It is the highest structure in the village, with St. Joseph Church a close second at 125 feet. The lone structure pictured here is now part of an elevator complex, with several other silos and bins nearby. (Courtesy of Farmers Elevator Co. of Manteno.)

This large white cinder-block building on Route 50 at First Street dates to 1936 and was built to house a Ford dealership. When the Ford agency moved, a roller rink opened (1938–1941); the building also housed a farm tools dealership—Allis Chalmers—operated in turn by Elmer W. Lawrence (1943–1947), Vince Dwyer (1947–1950), and Isadore and Vernon Ruder (1950–1960). This 1954 photograph was taken during the Ruder brothers' tenure before they moved farther south on Route 50. (Courtesy of Servants of the Holy Heart of Mary.)

This Manteno farmer poses with one of the township's mainstays in the farming industry—a Holstein. Of the seven breeds of dairy cattle in America, Holstein is the most common; it produces more milk than other dairy breeds. Identified by its black and white spots, the Holstein was first imported to America by a Dutch settler in 1621. (Courtesy of Minnich family.)

Until the 1950s, most people had their milk delivered. Harry Minnich Jr. (pictured here in 1940) began driving a milk truck at age 16 (in 1931); his route took him to Chicago businesses and homes. On October 22, 1942, He saw a car tipped over on the railroad tracks on Crawford Avenue in Midlothian (a Chicago suburb); he used a flare from his truck to flag down an oncoming train. The Chicago, Rock Island & Pacific Railway Co. thanked him for preventing a train accident. (Courtesy of Martha Minnich O'Connor.)

Birthplace of Harry Minnich Jr - Smith Farm

Large farms have historically had multiple homes so that family or hired hands could live close. The home pictured here in 1910, which belonged to Luther and Carrie Smith at the turn of the 20th century, has housed young families; before hospitals became the place to be born, home births were common. This was the case when Harry Minnich Sr.'s wife, Jessie, gave birth to their son Harry Jr. in this house in 1914. This structure is believed to have been renovated and is now part of a larger house owned by the Spanglers. (Courtesy of Martha Minnich O'Connor.)

4th of July

This late 1950s image illustrates farms as great settings in which to gather, with plenty of space and fresh air. Don and Barbara Stauffenberg hosted this group to celebrate the Fourth of July. Pictured in the front row of adults are (left to right): Don and Barbara, then Bernice Kruger and Maxine Rathje. The last names of others include Ruder, Kruger, Jacobs, St. Aubin, Klipp, and Rathje. (Courtesy of Susan Stauffenberg LaMore.)

Four

CHURCHES AND SCHOOLS

Just as farming has made Manteno what it is today, so has Christianity. The fact that various religions took hold in Manteno is a testament to tolerance, since it occurred against a backdrop of antipathy toward dissenting religious views that dated to colonial times. Quakers were persecuted in Boston (1660s), and Baptist ministers were thrown in jail in Virginia simply for publishing their views (1774), but the greatest hate was reserved for the religion whose leader resided in Rome. The year 1834 saw the burning of a convent in Charlestown, Massachusetts, and 1844 included the Nativist Riots in Philadelphia where two Catholic churches were burned. As recently as 1960, presidential candidate John F. Kennedy found it necessary to make a speech about his loyalty to America, not to the pope. As for Manteno, the Methodists, Presbyterians, and Catholics built the first churches in town, and they have lived in relative harmony. However, the divided cemetery in Manteno is a remnant from a time when Protestants and Catholics desired separation, even in death. Over time, more denominations have put down roots. In 2019, there were nine churches serving the community, all Christian.

People gathered in homes in the early days in the name of religion as well as the "three R's." At one time, school schedules revolved around harvest time, and many kids did not attend past eighth grade since they were needed in the fields or the family business. The Fair Labor Standards Act, passed in 1938, changed that. But from the industrial revolution through the 1930s, children working in various occupations were a common sight. Perhaps especially during the Depression (1929–1939), parents viewed high school as an unnecessary expense, especially for girls. At least one Manteno female had to pay back her parents for continuing through 12th grade during that financially devastating period; she likely was not the only one.

The one-room schools that used to dot Manteno's countryside were vacated in 1951 when the township voted to consolidate the former nine districts; thereafter, kids were bussed into the village to attend school. Those former country schools have been razed, moved, or renovated. Only a few still stand.

Methodists built the first church in 1857 on the southwest corner of Walnut and Division Streets; it was later used as a public school. When a new school was built in 1876, the old church was sold to the Minsier family and moved to the southwest corner of Main and Adams, as pictured above, with Our Lady Academy and St. Joseph Church directly south. When the church burned in 1898, reports said, "Mr. A. Minsier suffered a scorched face." In 1924, the home was moved again so that a grotto could be built in its place—this time to 312 South Oak Street. Harry Minnich Jr. and his wife, Mildred (Bowman), lived in the structure on Oak before renovations; their daughter Nancy remembers the lack of a front window on the upper level. In the 1950s, Harry Minnich Sr. raised the roof and turned the old church into apartments; it is pictured below in 2018, much as it has looked since the 1950s. (Above, courtesy of MHSMRM; below, author's collection.)

A new Methodist church on West Second Street was completed in 1872, pictured at right. The small spires that line the roof (three in front, one visible in the rear) are patterned after the large tower with a tall spire. The half-wall built to conceal the west side entrance results in a symmetrical look; the doorway appears, from the front, to be the same height as the surrounding side windows. The image to the right shows the church soon after it was built; the man standing in front is believed to be the builder of the church, Henry Brayton. Over time, all the spires sustained damage from severe storms and deteriorated. The tall spire was replaced with a four-sided hip-roof in 1904–1905, as shown below in 1917. The small spires were also removed, but for one whose base was retained. New stained-glass windows were also installed; the front window depicts Revelation 3:20, with Jesus knocking at the door. (Both, courtesy of Manteno United Methodist Church.)

Manteno United Methodist Church has continued to change and grow; a new spire was added in 1995 (left). Then, in 1998, ground was broken to add 8,600 square feet of space east of the building, including a multi-use fellowship hall, offices, and kitchen. The layout of the new addition also created an interior courtyard. Redbrick and white siding were used on both the new and old exteriors, resulting in a beautifully blended overall look. The image below shows the renovated church, which was dedicated in May 1999. (Both, courtesy of Jeff Jarvis.)

Presbyterians gather in the oldest structure to continuously serve as a village church. Built in 1859–1860 at Walnut and Adams Streets, its original sanctuary measured 36 by 50 feet, with a pulpit at the north end and a tower and gallery at the south end (shown above). The congregation discussed building a new church in 1903. Instead, in 1904, they agreed on extensive alterations to the original structure, including a new tower and belfry on the southwest corner, new pews, and lights. Its signature Good Shepherd window was also added to the south wall of the sanctuary. The church's history shines through its beautiful stained-glass windows; another was added to the fellowship hall, pictured at right. Designed and donated by Dr. Raymond Malott, it memorializes his wife (the former Ruth Jacobs) and newborn son; both died in 1962. Ruth Malott left behind five children. (Above, courtesy of MHSMRM; right, author's collection.)

The above image shows the Presbyterian church prior to 1926 before several wings were added to the east along Adams Street and to the north along Walnut Street. The barn in the background at left has vertical cladding, a gabled front, and a lean-to shed on the north side; when Manteno Grade School was built in 1926, it was razed. Visible in the background at right are homes that were razed for expansions to the church and the public library. The below sketch shows expansion to the north along Walnut, including a memorial chapel, kitchen, fellowship hall, education wing, and parking lot. Called First Presbyterian Church of Manteno until April 2019, its name was changed to Community Presbyterian Church when Peotone's congregation merged with it. (Above, courtesy of MHSMRM; below, courtesy of Community Presbyterian Church.)

Rather than build a new Presbyterian church, major alterations were made to the original church in 1904, including the addition of a furnace, new windows, and circular oak pews to seat 212. A series of three rolling partitions were also added, as pictured here; the partitions created a second room in the back, which was used for Sunday school. (Author's collection.)

Music brings people together. This 1905 image shows a quartet consisting of members of the First Presbyterian Church, as it was called at that time. From left to right are Luther W. Smith, Rev. Warren Goff, Charles M. Wright, and William H. Harvey. (Courtesy of Community Presbyterian Church.)

Catholics began meeting before the village was formed in 1869, worshipping in the home of Joseph Labrie northeast of town around 1855. Longtime resident Fred Holmes recorded that a structure on the Euziere property was shared by local denominations; however, since Euziere bought his home in 1880, that structure likely belonged to Alfred Deslauriers, who had attended the first Catholic mission mass. The rear of Deslauriers's property backed up to a half-block road that became Church Street (the only section in the entire town). In 1862, Rev. Pierre Paradis supervised the building of a small frame church with a single spire (pictured under construction at left) on the northeast corner of Walnut and Baker Streets facing Walnut Street. In 1877, a new church was built (pictured below). With two spires and mammoth proportions, it graced the northwest corner of Main and Baker Streets facing east until July 1898, when lightning struck the south spire and the church burned down. Insufficient water supply in town rendered the fire impossible to fight. (Left, courtesy of St. Joseph Catholic Church; below, courtesy of KCMPA.)

After the two-spire St. Joseph Catholic Church burned down, a new one was built, with one 125-foot spire. Its dedication ceremony in 1899 included sermons in French and English. This image is from about 1915. Today, the church's spire still dominates Manteno's skyline and issues a greeting to those who view the village from afar. (Courtesy of Susan Stauffenberg LaMore)

The interior of St. Joseph's, shown here in the mid-20th century, featured Gothic elements such as stained-glass windows and pointed spires. Murals behind the altar depict the holy family and the marriage of Mary and Joseph. The altar rail between the altar and seats was a barrier that came to be viewed by some as a symbolic division between priest and people. When architectural guidelines were changed, altar rails were removed. The seating is theater-style, with individual seats linked together. (Courtesy of St. Joseph Catholic Church.)

St. Joseph Catholic Church underwent a major renovation in the 1950s, with extensive changes as shown here. The 1947 lectures of Fr. H.A. Reinhold, a highly-respected liturgist, spoke of the ideal parish as one that encourages full participation. He stressed the role of church architecture. Father Reinhold called for "white-washed walls behind the altar," a standard of minimalism that relegated sacred wall paintings to the days of yore. Theater-style seats were replaced with white oak pews, which contributed to clean lines throughout. (Author's collection.)

Our Lady Academy boarding and day school was opened in Manteno by the Sisters, Servants of the Holy Heart of Mary. The academy's crest reflects its establishment in 1907. However, it was May 1905 when the nuns officially agreed to pay back the archbishop of Chicago for the cost of building the school, and memoirs of one of the founders list September 3, 1905, as the day the school opened its doors. The three-story brick school was due north of St. Joseph Church on Main Street. (Courtesy of MHSMRM.)

This 1911 image shows some of the first students at Our Lady Academy (OLA). The lone male is Aimie McNeil; the school was coeducational through eighth grade, but high school was for girls only. The teacher (first row, left) is Helen Ford. Also pictured are, in unknown order, Anna Gregg, Verdabelle Bourelle, Estelle Rosenthal, Ann Mae Riordon, Mary Malone, Irene Trepanier, Louise LaMore, and Loretta Smith. (Courtesy of MHSMRM.)

Mother Mary Catherine Fontaine, who grew up in Momence as Edna Fontaine, served OLA for 40 years. She taught from 1918 to 1921, was transferred elsewhere, then returned as high school principal from 1927 to 1956. When high school at the academy was discontinued she was reassigned again, and then returned in 1961 as grade school principal; she stayed until its closing in 1968. Having entered the novitiate in Beaverville in 1911 and taken her vows in 1914, her service to Catholic schools spanned more than 50 years. (Courtesy of MHSMRM.)

As OLA's reputation grew, the number of students increased, with many coming from Chicago and its suburbs. When enrollment outpaced space, a new, larger school was built on South Walnut Street (between Adams and Baker, facing west). Pictured is the second academy, which opened in 1920. The original school on Main Street was converted to a convent and boys' dorm. Boys were previously housed in two rented houses, including one that became the rectory. (Courtesy of MHSMRM.)

Many former OLA students went on to enter the convent, 20 of whom were from Manteno, including Sister Yvonne Brais, pictured here with her parents, Yvon and Jeanette Marie (Benoit) Brais. The proximity of the academy and the Presbyterian church is illustrated in this 1950s image on Walnut Street directly in front of the academy; the Presbyterian church is a half-block north. (Courtesy of Sr. Yvonne Brais.)

A house was moved so that this grotto could be built near the original Academy on Main Street. Dedicated in 1924, it was modeled on the grotto at Lourdes, where Bernadette Soubirous's visions in 1858 led to the founding of the Shrine of Lourdes. Pictured is OLA's class of 1927. From left to right are (seated) Agnes O'Connell, Florence O'Connor, Nora Keliher, Margaret Martin, and Florence Dunn; (standing) Mary Doheny, Mary Kennedy, and Mildred Cavender. Helen Welsh is behind Mary McGrath. In the background at left is Manteno Grade School on Walnut Street. (Courtesy of MHSMRM.)

When this grotto was built, the area around it was established as a park. When OLA closed, the village purchased the park. A stone from the Shrine of Lourdes that had been placed inside the grotto was removed, as were all religious statues. Local leaders later recognized its historical significance, and the property was purchased by St. Joseph Parish (reestablishing "the Catholic block"). In 1984, the grotto was refurbished, the Lourdes stone replaced, and the park was rededicated in honor of the sisters who had served the community. (Author's collection.)

This image shows the entrance of the second Our Lady Academy on Walnut Street, which had a concrete divided stairway leading up to the main floor and a single stairway leading down to the ground floor. Pictured is Manteno's local band; this photograph may have marked the October 19, 1924, dedication of OLA's grotto, park, and statues; a newspaper article indicated that the band

rendered "their usual brand of excellent music while Bishop F.F. Decelles (of Canada) blessed the newly-acquired property." Whatever the occasion, there are attendees of all ages, and the style of dress appears to reflect that of the 1920s. No nuns are pictured, but there is a priest at the top of the stairway at left. (Courtesy of MHSMRM.)

LAST O.L.A. HIGH SCHOOL GRADUATES

Top row, left to right: Joan Christoffel and Ella Therese Giroux. Center row, left to right: Mary Beth Feldmeier, Glenda Merten and Mary Elizabeth Buford. Bottom row, left to right: Mary Ann Martin and Sandra Snyder.

These girls were the last to graduate from Our Lady Academy High School in 1956. After this, OLA operated as a grade school until the Sisters, Servants of the Holy Heart of Mary closed it in 1968. Pictured from left to right are (first row) Mary A. Martin and Sandra Snyder (second row) Mary Feldmeier, Glenda Merten, and Mary E. Buford; (third row) Joan Christoffel and Ella Giroux. Mary (Buford) Howard went on to work at NASA. (Courtesy of Chris Russell and the *Vedette*.)

These OLA students would have graduated in 1957, except that the high school was discontinued in spring 1956. These girls transferred elsewhere (at least two went on to another Catholic high school). From left to right are (seated) Janet Wynn and Barbara St. Aubin; (standing) Mary Ann Brais, Diane Maisonneuve, Madonna Nugent, and Janet Cyrier. (Courtesy of Sr. Yvonne Brais.)

Baptists began building a church in Manteno in the 1870s, but it was never completed. By 1875, when the grade school on Walnut Street was being built, the unfinished church's foundation was repurposed and used. Baptist missions in Manteno popped up over the ensuing decades. In 1960, construction of a church on Park Street began. The auditorium was finished in 1961, and in September 1964, Manteno's Missionary Baptist Church was dedicated, led by Rev. Elden Light. (Courtesy of MHSMRM.)

Pictured are Cindy Blair and Bernell "Alex" Simmons, who were married July 25, 1970, at Manteno's original Baptist church on Park Street. The carpet beneath their feet is deep red, a color that signifies deep love; red also commands attention, thus its use at the front of the church. Cindy Simmons taught third and fourth grade in Manteno public schools for 36 years. She and Alex were married for almost five decades. (Courtesy of Cynthia Blair Simmons.)

In 1994, a new Baptist church was built on Third Street on the eastern edge of the village. When it opened, it bore a new name: First Baptist Church of Manteno. The new, bigger church has clean lines like the one on Park Street, plus a steeple. The new church also offers ample space for fellowship and religious study. (Courtesy of Patricia Goss Ligthart.)

The interior of the Baptist church on East Third Street is decorated modestly. The stained-glass window high on the wall draws the eyes of the congregation and creates a heavenly light that symbolizes the presence of God in the church. Below the window is the baptistry, which Baptists use for immersion baptism for members who have experienced the grace of God. The age of baptism varies, often in young adulthood. (Courtesy of Patricia Goss Ligthart.)

A Nazarene mission began in November 1945 with services at Legion hall. In 1961, the Manteno Church of the Nazarene was officially organized with 11 charter members, and in 1963, a permanent structure was built. That church on North Locust Street, shown here in the 1960s, also served as a parsonage for Ortive and Francis Welch and their children. A separate parsonage was purchased on Jan Drive in 1973. Renovations in 1996–1997 added a new 5,000-square-foot sanctuary and a family life center. (Courtesy of Manteno Church of the Nazarene.)

This 1970s image shows the interior of the original Nazarene church. When the structure was enlarged in 1978, this sanctuary was converted into a teen and youth room. Another addition to the church in 1997 included office space, gathering space, and a gymnasium. (Courtesy of Manteno Church of the Nazarene.)

This view of the original sanctuary of the Nazarene church is from the pulpit. In the front row at left, second and third from the left, are Dave and Connie Skinner. In 1980, Dave Skinner, of D.W. Skinner Organ Company of Manteno, built the Everett G. Lytle Memorial Organ with 2,256 pipes, which is still in use. The wall at the back of the room divided the sanctuary from a kitchen, which was the Welch family kitchen when the church was their home. (Courtesy of Manteno Church of the Nazarene.)

Pictured in 1982 are the first four pastors of Manteno's Nazarene church. From left to right are Rev. James Palmer (fourth pastor), Rev. William Scott (third), Rev. Lloyd Lunsford (second), and Rev. Frances Welch (first). In 2019, the longtime pastor of the church was Rev. Martha Krueger (not pictured). (Courtesy of Manteno Church of the Nazarene.)

Before 1951, when Manteno's nine school districts were consolidated, country children attended one-room schools located every two miles starting a mile from the village's boundaries. One example was Beedy School, on the southwest corner of Illinois Route 45 and County Highway 9. It is believed that the above c. 1914 image shows that school; the girl seated at right, second from the back (in plaid) is Alice Beedy. The redbrick schoolhouse was sold and converted to a private residence; though enlarged, the original structure is recognizable. Another example of country schools that surrounded Manteno is Bloom School, which was located in Rockville Township. The group photograph below is of Bloom School's class of 1931. Some of those pictured include two Paquettes (Lillian and Edward), three Beutiens (Eldon, Ellsworth, and William), three Gillands (Martha, Marie, and William), two LaMores (Juanita and Virgil), and two Goodwins (Arthur and Alice). The teacher is Cleo Bier. (Both, courtesy of MHSMRM.)

Schoolchildren attended classes in various buildings around town, including homes, churches, and a blacksmith's shop. This two-story, four-room school was built in 1876 on South Walnut Street to house all grades. In its first year of operation, 175 children were taught in three of the four classrooms. By 1906, township schoolchildren found that the school year had been lengthened to eight months. In 1907, high school was changed from a three-year program to four years; hence, the children who had expected to graduate in 1907 continued one more year. This photograph shows an addition off the back that increased classrooms to six (three upstairs and three down). Even so, the village continued to grow, and this school was used for just 50 years. It was razed in 1926 and replaced by a grade school in the same spot, with a separate high school built across town the same year. (Courtesy of MHSMRM.)

Both of these classes are posed in front of the all-grades public school on South Walnut Street. A few of the faces are the same in these two images; below are older faces. The girl at center in the first row above holds a sign reading "Manteno H.S. 1910–11." The group picture below is likely the class of 1911–1912; the only person identified is Clyde Harvey in the first row, second from right. It is believed that in the third row, fourth from right is Eoline Peters. (Above, courtesy of Mary Shy; below, courtesy of MHSMRM.)

63

These are some of the last high schoolers to attend the white frame school on South Walnut Street before it was razed in 1925. From left to right are (first row) Vernon Martin, ? Richmond, Franklin Bergeron, two unidentified, Carol Keller, Francis Trudeau, Lester Stauffenberg, Lionel Parker, Wilbur Hendrickson, Robert Klipp, Walter Jacobs, Leo St. Aubin, Holgar Bringelson, Nels Nelson, Arlo Dole, Allen Walton, and two unidentified; (second row, in unknown order) Beedy, Piper, Curtis, Reed, McElroy, Nelson, Giroux, Hendrickson, Grimes, and Jarvis; third from right

is Bernice Keller; (third row) Harry Imhauser, Ogden Wright, Erlan Shreffler, Haswell Kibbons, Claude Martin, John Lockie, Lester Chobar, Harvey Studtman, Marion Faulkner, Boots Guertin, Roland Oliver, Gerald Coates, Marvin Contois, Elmer Pepin, Emerson Nixon, Orell Simeur, Clem Shreffler, Luther Meyer, Milo Hendrickson, Dorothy Felten, twins Eoline and Evelyn Croxen, Dorothy Piper, Janet Mann, Gertrude Bringelson, Minnie Reed, Vivian Rathje, Elsie Schuman, Rena Mann, and Lorraine Barnes. (Courtesy of MHSMRM.)

Football was once more dangerous than today. The *Chicago Tribune* called the 1905 college season a "death harvest"—19 players died and 137 were seriously injured. Changes were made in 1906, but danger remained. Still, these Manteno public schoolboys from the class of 1910–1911 tossed the pigskin. Note one boy's archaic nose guard; his parents likely heard that Pres. Theodore Roosevelt's son broke his nose playing football in 1906. The game was deemed too rough by many Kankakee county schools; Grant Park has never had a team. (Courtesy of Mary Shy.)

Manteno organized its first football team in 1925, pictured here. From left to right are (first row) three unidentified, Boots Guertin, Emerson Nixon, and unidentified; (second row) Carol Keller, Vernon Martin, Lester Chobar, Luther Meyer, and Joe Belluso; (third row) Frederick Koepnick, Holgar Bringelson, Francis Trudeau, and Coach Shaw. (Courtesy of MHSMRM.)

Two new schools opened in the village in 1926. The old frame all-grades school on South Walnut Street was razed, and a new brick structure was built in its place. Manteno Grade School (above) served students in grades one through eight. Across town, Manteno Township High School was built on North Maple Street for all township students in grades nine through twelve, which necessitated the bussing of country kids into the village. The below 1931 image shows the high school with a gravel road in the foreground; the gymnasium's roof at the back of the school rises higher than the roofline of the classrooms at the front. (Above, courtesy of MHSMRM; below, author's collection.)

The two schools that opened in 1926 each had their own gymnasium with a stage, used for performances. Note the schools' acronyms above the stages—"MGS" for Manteno Grade School (above) and "MTHS" for Manteno Township High School (below). The grade school performance is from the late 1940s; it is believed that the woman with her back to the camera at center is longtime *Manteno News* reporter Lucille Thies (she used a high-backed wheelchair). The performance at the high school (below) is a play put on by the Ladies Auxiliary of the Presbyterian Church in October 1953. The women in the play are, from left to right, Alma Thompson, Millie Smith, Gertrude Phipps, Elsie Madison, Nelda Nusbaum, Ruth MacNeil, an unidentified little girl, and Hazel Hatch. (Above, courtesy of Martha Minnich O'Connor; below, courtesy of Community Presbyterian Church.)

This early 1927 image shows three Manteno Township High School students and a view of Main Street at that time. Note Euziere Elevator in the background at center and the triangular pediment of Citizen's Bank at left. From left to right are Luther Meyer, Milo Hendrickson, and Sam Wagner. (Courtesy of MHSMRM.)

These teachers are posed in front of Manteno Township High School in the early 1950s. Handwriting on the back reads, "Left to right, Miss Coronet, possibly Mrs. Naub, Mrs. Rogers, Miss Guimond, and Miss Hayes." Stella Guimond, who married Franklin Crawford, taught in Manteno for 42 years, many of which were spent teaching in country schools; however, the last 18 were in town. (Courtesy of MHSMRM.)

This 1941 image shows Manteno Grade School's basketball team. The coach is Dan LaRocque. In the second row, third from right is Leslie Hilsenhoff. Others include J. DeBouck, V. Gallois, C. Benham, M. Spargur, S. Potter, H. Stuart, N. Monnette, B. Gercken, D. Thompson, B. Hall, and F. Morris. During the late 1950s through the 1970s, junior high sports teams used "Bulldogs" as their mascot. The switch to Panthers for all grades was made by the 1990s. (Courtesy of MHSMRM.)

Pictured in 1943 is a Manteno Township High School girls' physical education class, comprised of juniors and seniors. From left to right are (first row) B. Viall, C. Weber, B. Schnell, Z. Kibler, M. VanNeste, D. Spanhook, M. Edmondson, T. Quirin, J. Rhodes, and D. Grant; (second row) F. Hartman, V. Hayes, B. Burns, B. Quirin, J. Hammond, E. Langlois, D. Buckner, J. Nourie, and M. Joyce, an advisor. (Courtesy of MHSMRM.)

On July 1, 1951, the township's nine districts were merged into State Unit 5 (the village had been District 5 of the 9). In 1954, a new, larger high school was opened on Poplar Street (pictured here in 1970). This school became Manteno Junior High School in fall 1974 when another new high school opened on North Maple Street. As population boomed in the 1990s, trailers served as makeshift classrooms until the school was enlarged. When a new elementary school opened on Cook Street in 2000, this school became Manteno Middle School (grades five through eight). (Courtesy of Manteno Community Unit District No. 5.)

Three major projects were undertaken in the late 1960s: an annex was added to the old township high school, which by then served as the junior high; the Poplar Street high school was enlarged to include space for industrial arts, "ag" class, and music; and a kindergarten wing was added to the southwest corner of Manteno Grade School (pictured). Much later, the brick grade school was razed and replaced by the current fire station. The kindergarten wing was saved and incorporated into the station. (Courtesy of Manteno Community Unit District No. 5.)

In Memoriam

Kenneth Haigh
May 19, 1924 ~ March 11, 1941

Many sports have been played by Manteno's high schoolers, but in the early years of the 20th century, there were just two: basketball and football. The latter was abolished when the coach was drafted during World War II, and the fill-in coach discontinued it after what he deemed "too many bad calls" in an out-of-town game. The football lay idle for 57 years until a team was formed in 2000. A rumor has circulated for decades that the sport was banned because a player was killed. Those from the classes of 1943 and 1944 attested to the falseness of the legend; no story appeared in the newspaper nor in Evelyn Viall's 1993 history of the town. It is possible that a memorial in a yearbook from that period (pictured at left) might have fueled the myth. Kenneth Haigh was a junior when he died at 16 of a ruptured appendix; trauma as a cause of appendicitis is possible, but rare. In addition to the reintroduction of football, students have taken part in track, cross country, baseball, softball, soccer, volleyball, golf, and wrestling. Pictured above is a match between Manteno and Herscher in 1972. (Above, author's collection; left, courtesy of MHSMRM.)

Bronze plaques engraved with the names of Mantenoans who served in World War I were attached to a large stone and placed on the schoolhouse lot corner at Walnut and Division Streets, as shown in the foreground of the above c. 1970s image. It was called a permanent structure, but the stone was removed about the same time the fire station replaced the old school, and the bronze plaques were erected on a new structure at Legion Park. The image below shows two children, Elaine Jacobs and Gary Stauffenberg, sitting on the cement base of the old memorial. The memorial is remembered by those who attended that school because it was essentially part of the playground where recess was held. (Above, courtesy of Manteno Community Unit District No. 5; below, courtesy of Susan Stauffenberg LaMore.)

Manteno's growth has continuously been reflected in its schools. Due to overcrowding, the school district rented space from two churches in the fall of 1966; kindergarten was held at the Presbyterian church, and high school band practice was at the Methodist church. Three new spaces opened January 1, 1967: an addition to the Poplar Street high school, a kindergarten wing, and an annex. But breathing room was temporary; the Servants of the Holy Heart of Mary announced that Our Lady Academy would close in spring 1968. Thus, the school board discussed how to absorb 160 more pupils into the public schools and decided to rent classrooms in the academy beginning in fall 1968. This rental situation continued for six years (1968–1974). The above image shows the third-grade class taught by longtime Manteno resident Cindy (Blair) Simmons at the academy. Below is the last school year (1973–1974) the academy was used as a public school (taught by Jeanne Slater). The academy building was razed a few years later. (Above, courtesy of Gloria Goss Wendel; below, courtesy of Robin Tober Betourne.)

The above image from the early 1970s shows the empty field upon which Manteno High School was built, facing North Maple Street. In the distance are two homes that were northernmost on that street at the time: 678 Maple Street, a two-story white farmhouse built in 1899 and once known as the Treffle LaMore home, and 610 Maple Street, a one-story brick ranch. Both homes still stand. The new Manteno High School opened in fall of 1974. Below is the school's original east-facing front entrance, with a sidewalk that stretched due east to a bus lane separated from Maple Street by a grassy parkway of about 50 feet. Two additions to the school have nearly doubled the original size. A wing was added to the east side so that the school is now closer to Maple Street. (Both, courtesy of Manteno Community Unit District No. 5.)

Manteno High School's class of 1974 was the last to graduate from the Poplar Street school. A new high school opened in fall of 1974 on North Maple Street; the graduating class of 1975 was the first to graduate from the new (and current) high school. The school on Poplar was repurposed for younger students. For decades, it has been a tradition for a collage like this one to be enlarged and hung on a wall in the commons area of the high school, so that succeeding generations could look back and see their older siblings, aunts, uncles, and other family members. These collages are still created each year and hang in the high school today, dating to 1955. Many in this 1974 image are still Manteno area residents, or their families reside nearby. (Courtesy of Mary Bowman Hyland.)

Five

MAIN STREET MERCHANTS

If Manteno were like Chebanse, a town 20 miles south that also straddles the original ICRR line, this chapter's title would be "Chestnut Street Merchants." Manteno changed its Chestnut to Main, but Chebanse mostly retained the Neal Plan developed by ICRR's David Neal in the 1850s. Chebanse also preserved its train depot, which means its current layout reflects a Manteno map of old—right down to roads that run parallel to the tracks, in the same northeast pattern.

Once dominated by a large black grain elevator with horse-drawn wagons lined up in front, Main Street is still the center of activity. Manteno's business district has historically been a three-block stretch of Main, bordered by Third Street to the north and Division Street to the south. Many have hung out a shingle along this busy stretch, from hardware or drug stores to ice cream or barber shops, as well as a movie theater. Most of what used to stand has either burned, been gutted, or had its front covered over so that it can be hard to envision what once was. But remnants remain, such as "C.P. Skinner 1904" etched into the structure at 121 North Main Street or "H. La Rocque 1895" on the building next to the old Wright/Butler storefront.

The oldest structure in this three-block section is the Rouleau Building, the former Klein's drugstore that Dr. Zephirin Rouleau purchased in 1881. Townsfolk believe this was built in the late 1860s, which means it dodged fires that repeatedly devastated businesses on the west side of Main Street before a waterworks system existed. Dr. Rouleau's medical practice was in the back of his drugstore, and he hired druggists to run the business. One of them would marry one of the doctor's daughters.

Every main street has its saloons, and Manteno is no exception. An old-timer said that there were once 10 bars in town, with many on Main Street, as with Tesseidre's, Harpin's, and Budd's Inn. In 2019, the Stampede Saloon was in a storefront to which Harpin's relocated in the 1960s when it moved a block south. Several businesses have moved from place to place. The moving about can keep a historian busy and cause disagreements among locals. By far, the distinction of for-profit business that moved most goes to the Candy Kitchen, as revealed in this chapter.

Main Street's merchants generally occupied this type of narrow, deep room—one lot wide; anything wider was a double storefront. These two photographs show the same room but with different owners. Sam Longtin (above, in the aisle at front) ran a general store in the early 1910s; the woman at far left appears to be his sister Anna Longtin, who became a nun with the Servants of the Holy Heart of Mary. Harvey Trudeau operated his general store in this same room starting in 1923 (below). This double-storefront building was owned by pioneer M. Brosseau & Son in the 1870s. Over time, other merchants ran businesses from the rooms on Main Street, including Reddish Grocery, Simeur's, Joe Maisonneuve's "exclusive" shoe store, Ferne (Dean) Felber's salon and shop, various drug and hardware stores, and saloons. (Both, courtesy of MHSMRM.)

From left to right are Joe Maisonneuve, Zephiere Longtin, and Samuel Longtin. Joe was one of 12 children born to Firman Maisonneuve, who moved to Manteno in 1890 after his first wife died in Kansas. Firman remarried Georgina Pepin, and they had 10 children. By 1910, the family had moved to Kankakee, and Joe, age 20, was living with the Longtin family (census records list Joe as a nephew). He followed his father into the shoe business but did not follow him out of town. Instead, he stayed and became a prominent permanent Mantenoan. (Courtesy of MHSMRM.)

This 1917 image captures the family of Harvey and Jane (Moat) Trudeau. Harvey took over the blacksmith and machine shop started by his father, Sefroid, upon his death in 1908. From left to right are (first row) William, Harvey, Helen Jane, Jane, and Louise; (second row) Harvey "Osmond" Trudeau. A book as a prop is a historical way to portray intellect in art. (Courtesy of MHSMRM.)

79

The c. 1900 image above shows the Wright Building (later the Butler Building), which still stands on the northwest corner of Main and Division Streets, although its original brick has been covered. Elnathan Wright purchased the property in 1833 to house a general store, later managed by his son Frank M. Wright. Adjoining the Wright Building to the north is the LaRocque Building. Going north is Manteno Citizen Bank, opened in 1893. The next building was originally owned by C.J. Boisvert; a double storefront, the north half housed E.W. Peters Hardware, later Peters & Harvey Hardware, and then W.H. Harvey bought out Ernest Peters and began offering funeral services in 1904. The below c. 1906 image shows W.H. Harvey and his father-in-law Milo Peters standing in front of the business. Harvey Funeral Home, later Harvey & Son, operated here until 1966, when Harvey-Brown-Long Funeral Home was formed. The business continues in 2019 under Brown-Jensen. (Both, courtesy of MHSMRM.)

Alfred Deslauriers (right) was one of Manteno's first merchants, running a grocery store on the southwest corner of Main and Division Streets from about 1854 until his death in 1875. Henry Townsend, who arrived about the same time as Deslauriers, bought the lot next door to the south and opened a paint store. Townsend later purchased the Deslauriers store and built a brick building to replace the old frame structure around 1892 (below). Called the Townsend Building, it has housed many businesses, including Alfred Letourneau's drugstore in 1900. (Both, courtesy of Dorothy Marie des Lauriers.)

Louis Towner married Eva Deslauriers (daughter of Alfred) and operated a general store on Main Street from 1882 to the late 1890s. Pictured in 1908 are Louis with his wife and children. From left to right are (first row) Artel, Louis, Philip, and Eva; (second row) Blanche (who became a nun and took the name Sister Mary Louis), Hervé, and Dulcine. (Courtesy of Mary Shy.)

A procession of stone buildings sprung up on Main Street after a fire decimated the business district in 1887. Leon Euziere erected this one in 1889, large enough to house three stores, which were snapped up by a hardware dealer, saloon, and the *Manteno Independent* newspaper. (Courtesy of MHSMRM.)

The name "Lockie" was sprinkled around the village from the time a young James Lockie entered the grain elevator business on Main Street with Leon Euziere and his landholding brother James married Medora Viall. Other Lockies included Lloyd, who was a brickyard manager, and Estelle, pictured here as a child, who became a schoolteacher. (Courtesy of MHSMRM.)

This 1910 portrait shows mother and daughter Angie (Beedy) Peters and Eoline Peters. Angie was the granddaughter of one of Manteno's earliest settlers, Daniel Beedy. She married George Peters about 1890, but by 1910, the census listed them as divorced. Eoline was granddaughter to Milo and Ellen Peters and niece of E.W. Peters, who owned a hardware store on Main Street. As was too often the case in the early 20th century, Eoline died young, at age 28. (Courtesy of MHSMRM.)

83

Alfred Deslauriers filed a plat for a small addition to Manteno in May 1856, then built the home pictured here on the northwest corner of Maple Street and Section Line Road. His property covered an entire block, with a caretaker's cottage in the back. Deslauriers reportedly allowed villagers to gather for church on his property; the half-block road abutting his west boundary became Church Street. Purchased by Leon Euziere, the home was a landmark until it was razed in 1971 to make way for Manteno State Bank. It is pictured here in 1931. (Courtesy of KCMPA.)

Manteno State Bank, established in 1946 at 15 North Main Street, had cashier cages, as shown in this 1954 image. They were removed in 1958. Pictured at far left is Stewart Switzer; the others are unidentified. After a bond was defeated to use the old Euziere property for a library, the citizens who had bought the land sold it to the bank. (Courtesy of Servants of the Holy Heart of Mary.)

Manteno has never had a shortage of saloons, despite temperance movements. Jules Teissedre ran the Crystal Knob Saloon in the Euziere building, pictured here in the early 1900s. Euziere's use of lower windows of opalescent leaded glass let in the sun but shielded patrons from the eyes of passersby, perfect for a saloon. With the passage of the 18th amendment in 1920, liquor went underground, literally. Locals wrote of a speakeasy in the north end of the Smith Building, concealed under the floor; a tunnel beneath Walnut Street connected it to the garage on the west side of the street, the former Fox blacksmith shop. (Courtesy of MHSMRM.)

The Darb Theater had an erratic history. In 1937, people came to see Shirley Temple, but the advent of television meant smaller theater audiences; by 1958, the Darb was open only on weekends. In 1961, nightly shows were back, and then in 1963, remodeling resulted in a small but expensive fire. It was never reopened. Cliff Owens gutted the structure and built apartments upstairs and offices downstairs. "Owens 1972" is etched into the building's front. (Courtesy of KCMPA.)

This c. 1953 image shows the original Manteno Candy Kitchen at 145 North Main Street, opened by Clara Mae and Bill Athanatos in 1937 and acquired by Kay and Ed Jugelt in 1947. In 1956, the Jugelts moved the Candy Kitchen one block south when the Athanatoses, who owned this building, returned to Manteno to open another confectionary in the same storefront. (Courtesy of Maxine Jugelt Kuehn.)

This January 1952 image shows the original Manteno Candy Kitchen with its wood-paneled walls and ornate trim. The waitress is Betty Senesac Reils; she had married Dwayne Reils in December 1951 just before this picture was taken. They were married more than 60 years. Claudia Benjamin, a teacher, is at far right. (Courtesy of Maxine Jugelt Kuehn.)

This advertisement appeared in 1957. Unable to use their old business name, Clara Mae and Bill Athanatos opened under the new name Clara Mae's. Coincidentally, another Clara Mae—Mrs. Russell Stover—started a hand-dipped candy business in Chicago in the 1920s; Russell Stover Candy went national, and when Russell died, Clara Mae Stover became company president. The Athanatoses, who hailed from Chicago in 1937, chose an effective name for their business. (Courtesy of MHSMRM.)

CLARA MAE'S

Home made Candies
and Ice Cream

Sodas -- Sundaes
Sandwiches
40 Years of Candy-Making
Experience

Fountain Service

2 doors South of Post Office

This 1956 photograph of Clara Mae's confectionary includes owner Clara Mae Athanatos waiting on three girls. Note the jukebox at the table. Later, Gordon and Pearl St. John managed this restaurant, and by 1964, advertisements touted "Gordy's: Home of Clara Mae's Fine Candies." (Courtesy of Servants of the Holy Heart of Mary.)

Kay and Ed Jugelt stand in front of the new location of their Candy Kitchen, one block south of the original; they operated here until the shop closed in 1965. Darb Theater and Hilsenhoff's, which offered fountain service from 1941 to 1955, were on the same block. Businesses moved around, as illustrated by the Candy Kitchen and also by Harpin's Tap, which by 1963 had moved a block south of its original location to 77 North Main Street, so that it was once again next door to "Kay and Ed's." (Courtesy of Georgianne Jugelt Buhr.)

Henry Simeur and Zephire Trepanier's first foray into the grocery business was in 1908, in the Euziere Building. Trepanier moved on, but the Simeurs stayed on Main Street for more than six decades. Henry's sons Orell and Ernest Simeur took over the store. They moved north a few doors to a storefront just south of Second Street. Pictured are Jack Shonkwiler (left) and "Ernie" Simeur with a customer. (Courtesy of Servants of the Holy Heart of Mary.)

When Ford Motor Company's 20 millionth automobile was manufactured, Henry Ford drove it off the assembly line in Detroit. The 1931 Model A slant window town sedan then toured America, and one of its stops was Manteno. Inside the car is Jane (Wright) Rogers. Standing in front of the car at left are, from left to right, W.H. Harvey, Clyde Harvey, and Leo Hassett; the others are unidentified. (Courtesy of MHSMRM.)

With automobiles came gas stations, some on Main Street. This late 1940s image shows a D-X gas station in the foreground at left. The station was run by John Dole and "Bump" Reed, and later by the Miller brothers. Formerly Diamond gas, these stations were rebranded as D-X around 1946. By 1965, D-X had merged with Sunray Oils and was one of the largest oil companies in the world. (Courtesy of MHSMRM.)

A raging inferno engulfed St. Aubin's Hardware store in January 1951. No one was hurt, but those living in apartments on the second floor lost everything. Firemen focused on keeping the adjacent businesses—a theater and a restaurant—from catching fire, which they succeeded in doing. The building was rebuilt as a single-story structure and continued as a hardware store until 1971. In 1975, Ferne (Dean) Felber turned it into a salon. (Courtesy of KCMPA.)

Opened by Everett Butler in 1937, Butler's Department Store is shown here in 1959. Originally opened in the old Wright Building, by this time, Butler had expanded his store into the LaRocque Building. Four doors north of Butler's is Manteno Hardware with a "Zenith" sign in front. Zenith Radio Corp. was founded in 1918 by two Chicagoans and produced many firsts, including the first wireless television remote control. (Author's collection.)

Six
AROUND TOWN

Around town, shadows of those who have toiled here are apparent. Be it the men who dug into a clay pit to form bricks, a husband and wife team who opened a small medical hospital, or farmhands who enabled local farmers to thrive and stay in business.

Many have worked in the name of Manteno's American Legion to honor those who have served, as well as to support the community in which they dwell. The Legion's influence is apparent all around the village. In 1954, the Legion paid for house numbers for residents, and the following year, it bought galvanized metal street signs and paid for their installation. It was then that the village dispensed with the original Neal Plan, and streets south of the depot were renamed. First South Street became Division Street, and the streets going south away from the depot were renamed Adams (formerly Second South Street), Baker (Third South Street), and Cook (Fourth South Street). Cook Street was the southern perimeter at that time, and it could have easily been named Adams so that the town's streets would have been alphabetical from south to north, followed by numbered streets. It is possible that Adams Street was named for Jerry Adams, who filled the jobs of streetlamp lighter in 1893, "pumper" for the waterworks in the early 1900s, and village marshal in 1916.

Some footprints from the past are visible only in the mind's eye, such as an empty field where a boarding school used to be. A grand farmhouse that once stood apart from the western edge of town now has a school in its backyard. Where men with shovels once dug into clay soil is a spring-fed lake. Parking lots line the railroad tracks where once there was an enormous black grain elevator, and of course, the train depot that started it all.

Hilaire Smith opened a modest shop on the corner of Walnut and First Streets in 1863, which turned into one of the largest carriage, wagon, and repair establishments in the county. His five sons joined him, and the name changed to H. Smith and Sons; by 1903, it became H. Smith's Sons. Pictured is Ed Smith offering a free clinic for farmers to learn small repairs for tractors. At far left is Julian Granger, Jack Moran is on the left tractor, and Richard Benge is at far right. (Courtesy of MHSMRM.)

Hilaire Smith replaced the original wooden structure that housed his carriage shop with a large square stone structure in 1911, which stands today and has housed several businesses, including a newspaper, public library, and publishing company. Pictured here is Manteno Lumber and True Value, which operated out of the Walnut Street side of the building and was owned and operated by Tim Nugent. Nugent sold the business and became Manteno's mayor in 2005. (Courtesy of MHSMRM.)

Sefroid and Martine (Brassard) Trudeau emigrated from Canada to Manteno in 1868, and Sefroid opened a blacksmith shop on the corner of Walnut and First Streets (facing Walnut). This photograph was taken around 1893 after two of Trudeau's sons joined him in business. The Trudeau home on First Street is visible to the west. Harvey Trudeau took over after his father died in 1908, and the wooden structure was replaced by a two-story brick building around 1911 (below). To the north on Walnut Street were two wooden structures. The first was a wagon shop, and the second was Henry Mongeau's veterinary barn, which Joe Fox later turned into a blacksmith shop. (Both, courtesy of MSHMRM.)

Winfred S. Beard had a buggy, equipment, and auto shop around 1905–1915. Note the signage for Acme Harvesting, a company formed in Peoria in the 1800s and a competitor of International Harvester, which also had roots in Illinois—Cyrus McCormick invented the mechanical reaper and opened the famed McCormick Works in Chicago, which later merged into International Harvester. (Courtesy of MHSMRM.)

Roads were once a significant source of grief when heavy rain meant getting stuck. This caused concern for farmers who needed to haul their crops into town. It also meant a limited social life for country folk. Car tires got stuck as often as wagon wheels. This scenario repeated itself with each rain until the construction of hard roads. (Courtesy of the University of Michigan Transportation History Collection.)

In 1905, the state of Illinois investigated the road problem. But the cost was prohibitive, and citizens balked at taxes. By 1916, a federal law was passed to match state funds in building highways with interstate importance. Under Gov. Len Small, construction of roads gained speed. By the end of 1930, Illinois boasted the best road system in America. This photograph shows a typical road construction crew in Illinois from that period. (Courtesy of the University of Michigan Transportation History Collection.)

Without enough housing for the number of laborers needed to build 5,000 miles of roads, the state established campgrounds along the route, which included basics such as water, an outhouse, and a small store. This is an example of one of the many campgrounds that popped up near road construction projects. (Courtesy of the University of Michigan Transportation History Collection.)

Joe Fox (left) served in World War I and was honorably discharged in 1919 in Madison County, Missouri. Joe, who would later open a blacksmith shop in Manteno, moved to the area from Missouri to help build what was originally Illinois Route 49 (now Route 50) on Manteno's eastern edge. He brought with him his wife, Mary Ellen (Clemons), and three children. They initially lived in a road-construction campground just north of town. Pictured below in the summer of 1928 are Mary Ellen Fox and their children in that camp (from left to right) Theresa, Paul, and Philip. It is not known how long the Foxes lived in the construction campground; any length of time in the camp had to be a trying experience with children in tow. (Both, courtesy of Kay Fox Jurica.)

Pictured in 1923 are Sylvester Keller (far right) and his sons. From left to right are Ralph, Lon, Earl, Roy, and Charlie. Charlie Keller married Uma Bowman and their son Carol wed Doreen LaMore. Charlie and son Carol fell prey to the narrow, nine-foot pavement between Manteno and Deselm: a head-on collision in 1938 resulted in Charlie's death at age 50; Carol survived. The road was widened in 1948 by laying narrow strips on either side of the original pavement, leaving a gap filled in later as funds allowed. Other accidents occurred before the widening, which included state hospital workers traveling from the west. (Author's collection.)

Manteno once had five miles of board and plank sidewalks, as shown here in 1931. Concrete was used in places starting in 1902. Then in 1939, the WPA approved funds for more concrete sidewalks for the village. The WPA completed more than 10,000 projects in 50 states during the Depression, including bridges, schools, and picnic shelters. Pictured here are Blanche (Keller) Bowman and her daughter Vera, age 11. (Author's collection.)

The old Trudeau shop, which was a chromium plate factory during World War II, was sold by Charles Barnes to the American Legion in 1948. Pictured is the flagpole dedication on September 11, 1949. The Legion's location at almost the exact center of the township is appropriate, for it has historically played a central role in the community. The Legion later acquired structures to the north along Walnut Street as well as the Trudeau home on First Street; these were razed to make room for additions and parking. (Courtesy of Manteno American Legion Post 755.)

This image shows the dedication ceremony held on September 11, 1949, at the Legion home, where it is still located 70 years later. Though most attendees are not individually identified, Margaret (Honnold) Phipps is seated in the back, and Oscar Russell (left) and Bob Kruger are standing at right. Others include Mayor Wilbur Hendrickson and post commander Paul Bagby. (Courtesy of Manteno American Legion Post 755.)

98

This late 1950s photograph shows members of the Ladies Auxiliary of Manteno's American Legion. Mary Catherine Curl, far right, served as auxiliary president in 1955 and is standing by as a past president as leadership is transferred once again, symbolized by the handing over of the gavel. The American Legion Ladies Auxiliary was founded in 1919 and had one million members nationwide in 2019. Members administer hundreds of volunteer programs. (Courtesy of Manteno American Legion Post 755.)

After Manteno's American Legion post was chartered in 1933, it bought Euziere estate land that had once housed a haybarn—a half-block site bordered by Third, Main, and Fourth Streets—with the intention of building its permanent home. The post instead repurposed the old Trudeau machine shop and turned this land into a park. Over the decades, Legion Park has hosted baseball leagues and motocross races, and above all, is a place that honors Mantenoans who have served the nation. (Author's collection.)

Mary Ella Van Neste graduated from Manteno Township High School in 1944, and during World War II served as a member of the US Cadet Nurse Corps at Great Lakes Naval Hospital. She later graduated from St. Mary's Hospital School of Nursing and worked 33 years at Manteno State Hospital. Mantenoans would also know Mary Ella as Mrs. Jesse Dixon (her first husband) or Mrs. James Farrell (whom she married after being widowed). (Courtesy of MHSMRM.)

Manteno has continuously endeavored to honor its fallen, as illustrated by this 1945 *Manteno Independent* clipping. This list includes those who died in service during World War II. Many of the names are recognizable; some of these families are still in the area today. (Courtesy of Chris Russell and the *Vedette*.)

MANTENO INDEPENDENT
Thursday, April 5, 1945

Published Every Thursday at
115 Church Street,
Manteno, Illinois

Dan Sanborn	Publisher
Frances Durand	Editor
Dolph Williams	Plant Supt.

Entered at the Post Office, Manteno, Ill., as second class matter.

Single copies	5c
1 year's subscription	$2.50
Servicemen, 6 mos.	$1.25

LEST WE FORGET...

★ Alfred Brandt ★
★ Robert Boughton ★
★ Everell Guimond ★
★ William Hoenk ★
★ Dallas Hopkins ★
★ Joseph McGrath ★
★ Willard Petrie ★
★ Paul Ritter ★
★ Armand Senesac ★
★ William Wright ★

"... We here highly resolve these dead shall not have died in vain..."
Abraham Lincoln,

100

Ronald "Ronnie" Gray graduated from Manteno High School in 1968 and then entered the military during the Vietnam War. He had just turned 19 when he was killed on May 12, 1969, in South Vietnam. He is pictured here in 1968 as he graduated from boot camp. Gray was well known in Manteno; Township Road 10000N, formerly Manteno Lake Road, was renamed Ronnie Gray Drive. It runs along Legacy Park as it stretches west from Maple Street. (Courtesy of William Beutien.)

This is a pencil rubbing of Ronnie Gray's name from the Vietnam Veterans Memorial wall in Washington, DC. Another man listed on the wall gave Manteno as his residence when he entered the service, Johnny H. Lawrence, though he hailed from Oklahoma. It is not known how long Lawrence lived in the village (he did not attend Manteno High School), but he died in 1971 at age 26 in South Vietnam. (Author's collection.)

W.R. DeVeling began publishing the *Manteno Independent* newspaper in 1886 with John D. Breen as coeditor. The paper changed hands and locations, and finally had a 32-year stint with Arthur M. Decker at the helm through 1943. The three people above also appear below, which suggests that one is Dan Sanborn, who bought the *Manteno Independent* in 1945 and moved it from 115 Church Street (above) to a room in the bowling alley building at Oak and First Streets (below), at which time he renamed the paper the *News of Manteno, Grant Park, Whitaker, and Deselm*, or *The News* for short. (Both, courtesy of MHSMRM.)

Three Moisant brothers, Medard, Raphael, and Jean Baptiste, came to Manteno; the latter went by J.B. Moisant and opened Manteno's first livery before traveling the show circuit with Cooper, Bailey & Co. in the 1870s. Medard moved his family to Manteno about 1879, perhaps running one of the three Manteno farms his brother J.B. owned by 1883 after his return to town. Medard, Josephine, and their seven children lived in Manteno until about 1887; three of their children would make headlines. Their son Jean Baptiste, going by John Bevins Moisant, built the first all-metal airplane, the Moisant biplane, and was the first to fly with a passenger over the English Channel in 1910. John and brother Alfred formed Moisant International Aviators. But John crashed during an air show in New Orleans and was killed on December 31, 1910. That site became an international airport; its identifier, MSY, stands for Moisant Stockyards. Alfred Moisant continued the business, and in 1911 brought a show to Kankakee County fairgrounds, as advertised in the poster at right. (Both, courtesy of KCMPA.)

Great Inter-State Fair
AT KANKAKEE, ILLINOIS.
$30,000 Races, Premiums and Attractions
September 4, 5, 6, 7 and 8, 1911.
GRAND OPENING ON LABOR DAY

Different from all others—novel, new and entertaining. A great combination of Agricultural Fair, Carnival, Circus and Horse Show. No other Fair like it. It is the greatest outdoor entertainment ever given. Five full days and evenings of Fair.

MOISANT INTERNATIONAL AVIATORS

RENE SIMON and JOHN J. FRISBIE,
BOTH FIRST MONEY WINNERS AT THE CHICAGO INTERNATIONAL AVIATION MEET,
will sail among the clouds at the Fair on Monday and Tuesday. Exhibition will consist of starting and alighting, bomb-throwing, altitude flights, and on Tuesday a five-mile race between MOISANT MONOPLANE and CURTIS TYPE BIPLANE.

SATURDAY—ARRANGEMENT DAY.
MONDAY—GRAND OPENING DAY.
TUESDAY—AVIATION DAY.
WEDNESDAY—KANKAKEE DAY.
THURSDAY—POLITICAL DAY.
FRIDAY—HOMECOMING DAY.

Ex-Mantenoan Alfred Moisant opened Moisant Aviation School on Long Island. Among his first students in 1911 were his sister Matilde Moisant and Harriet Quimby. Quimby became the first licensed female pilot in the nation; Matilde became the second and won the Rodman Wanamaker Trophy for altitude in October 1911. A month later, in Mexico for the Moisant Meet, Matilde dropped a flower bouquet from the air onto the patio of the Mexican president's home. He commented, "It was good it wasn't a bomb." To which Matilde quipped, "Just a bomb of friendship." (Courtesy of Smithsonian National Air & Space Museum.)

Another aviation family are the Spanglers, starting with Russell Spangler, pictured here in 1966 with grandsons Larry and Bryan. Russell took flying lessons in the 1950s, bought an airplane, and put in a grass airstrip at his farm on Manteno's west edge. The Spangler hangar filled with neighbors' airplanes; some for recreation, others for crop-dusting. Russell's son Robert also had an airplane, and Robert's son Bryan has carried on the tradition with his own airplane on land that has been in the Spangler family over six decades. (Courtesy of Bryan Spangler.)

At one time, more than one tenth of the production of common brick in America came out of Chicago yards. Manteno joined the brick boom in 1906 when investors formed the Manteno Brick and Tile Company and purchased 21 acres north of the village on which to build their operation. Dan G. Lee was president, and J.F. Schmeltzer was secretary. By 1908, manufacturing of Manteno brick began. Pictured above is a Marion Shovel (from Marion, Ohio, "the city that built the Panama Canal"). By 1913, Curtis Brick Company, which operated a brickyard in nearby Grant Park (Curtis Plant 1) acquired the Manteno yard, making it Curtis Plant 2. When Chicago's largest brick manufacturer, Illinois Brick Company, acquired Curtis, Manteno was absorbed as well. The 1913 aerial sketch below shows Curtis Brick Company as the owner of the Manteno brickyard; note the absence of Illinois Route 50. (Above, courtesy of MHSMRM; below, courtesy of Cornell University Library collection.)

Curtis Brick Company's Manteno, Illinois, Factory.

Many Mantenoans worked at the brickyard; names on the payroll included Reed, Alsip, Butler, Gallois, Senesac, and others. Some laborers migrated between the Manteno and Grant Park brickyards as employment dictated, and took their families with them. The author's grandfather Homer Bowman was one—his daughter Mildred wrote a history for the local newspaper that said her family came to town as "brickyard folks." (Courtesy of MHSMRM.)

Digging in a clay pit is a dirty job, as the faces of these brickyard workers testify. The clay (or mud) was dug up and put into a brick machine that chopped it up; the clay was mixed and rolled, then cut into eight-inch bricks. As the bricks moved along a conveyor belt, men picked them off by hand and put them into steel carts headed for the drier, then the kiln. (Courtesy of MHSMRM.)

The brickyard kilns were ovens used to "fire" or bake the brick. In the early days of operations when wood was used, it took six days and nights to accomplish the task; with crude oil, that time was cut in half. After firing, it took a week for the "burnt" brick to cool before being shipped out on railroad cars. The kiln shed, with four smokestacks, is pictured here. (Courtesy of MHSMRM.)

When the brickyard began, it was mostly a manual operation, but after Curtis Brick bought the company it was mechanized, adding an overhead crane in the kiln shed, pictured here. Frank Payne, who worked in this shed until the last brick was made in December 1928, described how up to 30 kilns could be housed in the enormous shed at one time. (Courtesy of MHSMRM.)

Brickyard workers hit a natural spring, and only by continuous pumping of water were they able to continue working in the clay pit. A combination of factors caused the brickyard to close: rising freight prices and the arrival of hard roads in the 1920s meant builders near Chicago turned to brickyards closer to building sites. The last Manteno brick was made in December 1928, and when the pumping stopped, the pit filled up. The kiln shed was dismantled, its timber shipped to a nearby coal mine to use as props (possibly Essex, which had a mine from 1928 to 1956). The old pit grew to a lake of 38 acres, with a maximum depth of 18–20 feet. A 1939 article speaks of planting vegetation "to attract wild game birds" and stocking the lake with fish. Locals formed a sports club, Club 37, to honor its history as Illinois Brick's plant 37. In 1940, a 22-by-40-foot structure was built for members—it is pictured here at top right. That building was auctioned off in 1953; Don Stauffenberg bought it for $50 and moved it to his farm. Its "bones" have been incorporated into a home that still stands. (Courtesy of MHSMRM.)

Club 37 has provided family entertainment since its inception; for example, Manteno's homecoming was hosted on its grounds in 1943. By 1954, the name had been changed to the Sportsmen's Club, and a headline touted 10,000 patrons for its Fourth of July celebration. This late 1980s image shows boat docks to the left of the clubhouse and a small section of fenced-off beach to the right. The clubhouse appears to have been constructed of rock-faced concrete slabs, possibly manufactured by Manteno merchants Kehler and Martin, whose plant was located on East First Street, a half-block east of Oak Street on the alley. This photograph shows how the clubhouse was enlarged in the early 1980s so that it took on a cruciform shape. On the west side of the lake stands just one house. In the foreground at left is a tennis court (later converted to a parking lot), and nestled among the trees at far left is a playground. (Courtesy of Manteno Sportsmen's Club.)

In April 1956, the Sportsmen's Club began building a beach and asked for "volunteers to wield a shovel or a truck." By June, the beach was open from noon to 10:00 p.m. A lifeguard was on duty until 5:00 p.m. Monday through Saturday. The club sought volunteer lifeguards for evenings and Sundays. This c. 2000 aerial view shows lovely lake homes built along the water's west edge. The beach is to the right, north of the clubhouse. (Courtesy of Manteno Sportsmen's Club.)

This c. late 1970s image shows the manmade beach built by the Sportsmen's Club in 1956; its footprint is largely unchanged since that time, including the original concessions structure; however, certain amenities have been added or improved. Longtime members will remember the logs that served as the perimeter of the swimming area, past which no one could swim, and the 1960s diving board atop a platform several feet above the water's surface, supported by metal poles. (Courtesy of MHSMRM.)

Pictured at right in 1940 are Frank Renchen Jr. and Vera Bowman at her home; behind them is the stone wall that comprised the lower level of the structure (Vera's family lived in the upstairs flat of the old Wright creamery). Frank had lost an arm in a car accident in 1939. He and Vera married, farmed, and founded Sunny Acres trailer court in 1966, a timely addition just as housing for state hospital staff was about to end and Interstate 57 was about to open. Note the shuttered window behind the couple; there were windows built only into the south, east, and west sides. As a creamery, there was no need for windows on the north side, which faced town. Though villagers saw a windowless red box of a building surrounded by cornfields, on the inside, the nine-room flat resembled other homes built in 1875. The below image shows the large kitchen with detached cabinets; built-in cabinetry was not common to homes until the 1920s. Pictured are Nedine Lemenager Bowman (seated) and daughter Marla. (Right, author's collection; below, courtesy of Mary Bowman Hyland.)

Born in New York and raised in Wisconsin, Amanda Hillman graduated from the National Medical College in Chicago in 1899; she then worked in a Chicago mission before entering the Women's Foreign Missionary Society of the Methodist Episcopal Church. Hillman worked in Seoul, Korea, from 1911 to 1914 (left). During this time, she was one of six American doctors, all female, at PoKuNyoKwan, an institution founded in 1893 that cared for women's physical and mental health, and that offered Korea's first nurse training program, the cradle to produce Korea's first female doctor (Esther K. Pak). Japan annexed Korea in 1910 and abolished its government in 1913, and by 1914, missionaries were being expelled, including Hillman. An impoverished widow and mother of an ill five-year-old daughter asked Hillman to adopt her child. That girl's name was Chansuna Kim. Dr. Hillman took Kim with her back to America; they arrived together in August 1914 at Angel Island immigration station in San Francisco. Chansuna's name was changed to Naomi (below). She became a doctor and cofounded Hillman Memorial Hospital on Division Street. (Both, courtesy of Dorothy Hur Reilly.)

Daniel Hur was born in Korea and was held as a political prisoner before escaping to China in 1920 and emigrating to America in 1922. He attended Northwestern University near Chicago, where he met Naomi Kim, and they married in 1931. They both began working at Manteno State Hospital in 1936 and maintained a joint practice on the second floor of the Wright/Butler Building on Main Street for years. Dr. Hur, who retired about 1977, was still seeing a few patients when he died in 1978. He is well-remembered by Mantenoans. (Courtesy of Dorothy Hur Reilly.)

When the doors of the new Hillman Memorial Hospital on West Division Street opened on February 2, 1948, it consisted only of the building with the peaked roof seen at right in this 1970s image. Founded by husband and wife Drs. Naomi Kim and Daniel Hur, the hospital was largely designed by Dr. Hur, who had studied architecture, and was named for Kim's adoptive mother, Dr. Amanda Hillman, who brought Kim to the United States from Korea in 1914 when Kim was five. (Courtesy of MHSMRM.)

When Hillman Hospital opened, there was no maternity ward. Four months later, that changed. On June 22, 1948, Joan (Carlos) Nugent was in late-stage labor, and her husband, Leo, took her to Hillman. Soon, Hillman's first baby was born, Karen Nugent, followed by Kevin Nugent, her twin. It was a surprise to everyone. Hillman had no newborn supplies, so Leo brought two bassinets from home. The Nugents had two more babies at Hillman, Tim and Joel (not twins); by then, Hillman was ready to birth babies. Pictured is Joan with Kevin and Karen at two weeks old. (Courtesy of Kevin Nugent and Karen Cassidy.)

Drawings from 1955 show plans to add a wing to Hillman Memorial Hospital; the new wing was dedicated in 1957, pictured here. The addition had a new operating room, more patient rooms, and facilities for a laboratory and pharmacy. There was a separate building in the rear that housed nurses. (Courtesy of MHSMRM.)

HILLMAN HOSPITAL PURCHASES LAND

The purchase of land across the road from the Division street entrance of Hillman Memorial hospital has been announced by Dr. Daniel K. Hur, hospital administrator.

The property was acquired from the Omer Audette estate. Landscaping and other improvements of the land will begin soon, he said.

Dr. Hur also revealed that plans are under way to erect a laundry building on the hospital grounds. Architect plans have been submitted to the state for approval.

Cost of the building and its equipment is expected to exceed $15,000.

Future plans for the former Audette property include parking facilities for the hospital.

Pictured on the site of land recently bought for Hillman Memorial hospital are Dr. Daniel K. Hur, administrator; Jack Moran, president of the Manteno Medical Foundation; Isadore Ruder, foundation director; Miss Mildred Davis, nurse's aide, and Miss Barbara Fiffer house and grounds keeper.

Unable to be present were Rodney Mann, vice president; Norris Curl, director; Edmond A. Smith, treasurer, and Miss Beedy, secretary.

Officials of the hospital report that this is just one of the many expansions since the local hospital was established in 1948.

This newspaper article shows how Hillman Hospital continued to grow. The land across the street on Division was purchased to provide additional parking for the facility. Visible in this image in the background at far right (next door to the hospital, to the east) is the home built by Drs. Hur and Kim, which was the family residence. Though they stopped running the hospital around 1977, their home was owned by their daughter until 1997. The hospital has since been turned into a substance abuse facility. (Courtesy of Chris Russell and the *Vedette*.)

Drs. Kim and Hur had one child, Dorothy. She attended Manteno Grade School on South Walnut Street for grades one through eight (1942–1950), then attended a boarding school in a Chicago suburb for grades nine through twelve. Some who were patients or employees at Hillman Hospital may remember Dorothy; she worked various jobs around the hospital once she was old enough. Though Dorothy moved away, Manteno was "home" for many more years. (Courtesy of Dorothy Hur Reilly.)

115

Manteno's police car was equipped with a radio in 1952, as displayed in this image of Milo Hendrickson. Milo, who became fire chief in 1964, was one of five children born to John and Izola Hendrickson, the three youngest of whom died within days of each other during the flu pandemic of 1918–1919—one of the deadliest in history. A total of 50 million died worldwide, with 675,000 in America. (Courtesy of MHSMRM.)

In May 1947, when the Manteno Fire Protection District was organized, the newest fire truck belonged to the township, bought with the donations of farmers. Taxes were levied, and the district was established with a fire station adjoining village hall on Main Street. After the old grade school on Walnut Street was razed in September 1978, a new station was built in its place (pictured). Manteno later built a small station at the northwest corner of what used to be the state hospital grounds. In 2019, the community fire district covered 12,000 inhabitants. (Courtesy of MHSMRM.)

Pictured in January 1959 are, from left to right, Bob Kruger, Cleo Guertin, and Jim Long at Kruger's Food Center & Locker Plant. Located a half-block west of Main Street on West Second Street, Bob and Bernice (Wiechen) Kruger operated this business from the 1940s through the late 1970s. This was one of many resident-owned grocery stores over the years. Kruger's also butchered onsite. Residents tell of cows that were brought to the entrance on the alley. The town has just one grocery store now: the Illinois-owned-and-operated Berkot's. (Courtesy of MHSMRM.)

The Blizzard of 1967 lives on in the minds of many Mantenoans. Snow began falling at 5:00 a.m. on January 26 and continued for 28 hours, blanketing northeast Illinois with 23 inches of snow. Travelers along Route 50 were stranded, as were 800 state hospital employees. The Legion and Nazarene church housed travelers and school kids (school buses could not traverse country roads). Neighbors pulled together, and kids got out sleds. Pictured just days after the blizzard are mother and daughter Eloise Long (left) and Bethany Long Harms. (Courtesy of James Long and family.)

The Deslauriers/Euziere home was razed in 1971. Darb Theater was gutted the same year. Then Euziere Elevator was demolished, followed by Our Lady Academy, as well as the grade school on Walnut Street. Mantenoans saw too much history disappearing too fast, so when the depot was razed, Nelda Nussbaum spoke up. The outcome was the Manteno Historical Society. Stella (Guimond) Crawford helped with the purchase of the old Skinner home (pictured here in 2019), and a museum has existed there since 1992. The renovated portico (with a glass front) showcases Dr. Rouleau's buggy, which he used until his death in 1913. An addition on the back of the museum houses a genealogy research room. (Author's collection.)

Seven

MANTENO STATE HOSPITAL

America's first psychiatric hospital was built in 1773 in Williamsburg, Virginia. With the help of crusader Dorothea Dix in the 1800s, a wave of state-funded mental institutions swept the nation. A precursor of the American Psychiatric Association was the Association of Medical Superintendents of American Institutions for the Insane, formed in 1844. The word "insane" described those with various disturbances; thus, early mental hospitals were called insane asylums. The first in Illinois opened in 1851 in Jacksonville, the Illinois Hospital for the Insane. In 1879, the Eastern Hospital for the Insane opened in Kankakee. By the time Manteno opened, these facilities were called "state hospitals."

In 1927, under Gov. Len Small of Kankakee, the state appropriated $1 million to build a state hospital. In 1928, the state purchased three Manteno farms owned by brothers Emilian, Zephere, and Alec Senesac. Oliver Barnard originally owned the land upon which the hospital was built, but his farm had been absorbed by Emilian Senesac in 1919. Construction began in May 1929, and a dedication ceremony took place in November. The first 100 patients arrived on December 27, 1930.

In early 1939, a typhoid outbreak at the state hospital resulted in 60 deaths, and the *Manteno Independent* questioned the decision to build east of Manteno in an area with "poor drainage and questionable water supply." Whatever drove the choice of location, the importance of Manteno State Hospital to the township and county cannot be overemphasized.

Called "Hospital City," the institution was largely self-sustaining with its own power plant, police and fire departments, medical hospital, staff housing, and massive kitchen that processed food grown on the hospital's four farms. The patient population was 838 by 1932, and by 1938, it was 3,692. It peaked in 1955 at 8,272, but with the rise in aid to nursing homes and shelters, the patient population plummeted to 1,000 in 1977. Still, there were 1,385 employees that year, and of those, 800 were in direct patient care. People moved to Manteno to work at the hospital, many of them doctors. All of this changed the face of the community.

August 1975 saw the name changed to Manteno Mental Health Center (MMHC). By December 1985, the facility closed. Before there were addiction treatment centers, there was MMHC's alcoholism program. Others spent time there for conditions such as bipolar disorder or depression. The closure of MMHC has had ripple effects that are apparent today.

Construction began in May 1929 on eight two-story "cottages" (wards), four each for female and male patients. English Brothers Construction Co. of Champaign was the contractor for the first eight cottages, administration building, power plant, main dining room and kitchen, Brandon Hall, and five doctors' homes. Construction crews earned $1.25 per hour for a 44-hour week. (Courtesy of KCMPA.)

The foundation was laid for the administration building in September 1929, including a cornerstone etched with "1928." Pictured is the dedication ceremony held November 21, 1929, where state officials declared that "Manteno" (the common moniker used by non-Mantenoans) would be the "tenth such hospital to be dedicated by the State of Illinois for the welfare of its people, for their relief and restoration." In this crowd were Dr. Ralph Hinton (first superintendent), A.L. Bowen (director of state charities), and Kankakee mayor Louis E. Beckman. (Courtesy of KCMPA.)

This image shows the farmhouse built in 1869 by Oliver Barnard, who originally owned the land upon which the state hospital was built. For decades, this house was the first glimpse of the grounds for anyone entering; it was located at the entrance on Barnard Road, named for the settler. It was renovated and used as a residence by hospital superintendents beginning with the first in 1930, Dr. Ralph Hinton. (Courtesy of KCMPA.)

After passing the superintendent's residence at the entrance, visitors would traverse a long driveway that led to the regal administration building. Its size and location presented like a fortress, and vehicles entering or exiting the grounds had to navigate around it. Though the hospital closed in 1985, this structure still stands. It has housed offices for a local bank for many years. (Courtesy of Phil Tkacz.)

121

The Eastern Hospital for the Insane was renamed Kankakee State Hospital in 1910. This c. 1913 postcard shows the hospital's location near the banks of the Kankakee River. One hundred men were transferred from this institution to become Manteno State Hospital's first patients on December 27, 1930. The men arrived by train; a spur just south of the village left the mainline and deposited them directly at the grounds. (Author's collection.)

At Manteno State Hospital's 1929 dedication ceremony, Illinois director of public welfare Rodney Brandon announced that it would be the tenth such institution in the state for "unfortunates" to receive the best treatment possible. In fact, Illinois's newest hospital would go on to become one of the largest in the world of its kind. When the 1938 Illinois State Fair was held, this plaster of Paris model was displayed. (Courtesy of MHSMRM.)

This early 1960s map shows the state hospital's campus, with fire zones marked. The hospital was a veritable city with a population triple that of the entire village; the average in the early 1960s was about 7,000 patients. There were also 1,000-plus employees representing 50 trades and professions (medical, mechanics, cooks, fire, security, power generation, and so on). The original eight patient wards, built in 1929–1930, were named Addams, Barton, Dix, and Gollmar for women, and Dewey, Pinel, White, and Wines for men; all were named for someone whose role was important to public welfare, nationwide or worldwide. Some names are well-known, such as Jane Addams and Clara Barton. This map shows the rail line that entered the campus from the west. Illinois Central installed a switch from its northbound main tracks, and one spur led to the hospital's powerhouse, while the other led to a platform near the general store and kitchen. This rail line traversed land formerly owned by Amie Benoit and facilitated the transport of food and supplies necessary to run the hospital. (Courtesy of MHSMRM.)

Named for Rodney H. Brandon, director of the Illinois Department of Public Welfare when construction began, there were two Brandon buildings. Brandon I (pictured here) and II housed employees, who were separated by gender and marital status. This was one of several buildings that radiated due north and south from the administration building along the campus's east border, most of which were not for direct patient use in the early years. (Courtesy of MHSMRM.)

Pictured is Bowen hospital, where patients were treated for physical ailments, including the typhoid outbreak of 1939—with 450 cases and 60 deaths. Typhoid fever, rare in America by then, can come from drinking water polluted by sewage. The *Manteno Independent* ran a front-page article in the epidemic's aftermath, questioning the decision to build the state hospital in an area with "questionable water supply." Chlorination of the campus's water was begun after the epidemic was underway. A.L. Bowen, state director of welfare, was found guilty of malfeasance for failure to act on warnings of contaminated well water. (Courtesy of MHSMRM.)

Architecture of mental hospitals as a tool for treatment brought about a revolution in the layout of these institutions in the last decades of the 19th century. Rather than a massive structure with a centralized administration and receding wings to each side, hospitals began being built using the cottage plan with multiple smaller buildings that allowed for the complete classification of patients (violent/passive, men/women, geriatric, and so on). Pictured here is Meyer Cottage around the 1950s; Bowen hospital building is in the background. (Courtesy of Phil Tkacz.)

Hydrotherapy rooms like this one were common in mental hospitals in the 20th century. Manteno hospital used hydrotherapy at least through 1949. A canvas suspended across the bathtub's rim could restrain (if needed) until the "calming" took effect; the canvas also kept the head above water for this three-hour soak. Other treatments included insulin-shock therapy, electroconvulsive therapy (ECT), and psychosurgery, such as lobotomy. With the advent of psychotropic drugs, these treatments were discontinued; however, forms of ECT continue in the 21st century. The last lobotomy in America was performed in 1967. (Courtesy of Library of Congress Prints and Photographs Division.)

State mental hospitals used medical interventions along with a combination of exercise, amusement, and physical labor. Pictured is Hinton Hall, named for Manteno's first superintendent, which housed a gymnasium for exercise and space for "amusement therapy," such as indoor bowling leagues, dances, and movies. Physical labor performed by patients included farming at one of the hospital's four state-owned farms (which provided food for the campus), working in the laundry, lawnmowing in summer, or doing piece-work such as assembling toys for cereal manufacturers. (Author's collection.)

This 1967 map of the hospital campus reflects updates made since the early 1960s, including a new laundry (touted as "the world's largest"), a three-million-gallon reservoir (to prevent water shortage in case of a break in the line from Kankakee Water Company), and two buildings that formerly housed employees in the northeast quadrant being repurposed for nurses' offices. More changes were in store as the state hospital's population steadily declined from 5,400 in 1967 to just 1,000 patients in 1977. (Courtesy of MHSMRM.)

In 1930, two-story dormitories, each with 52 rooms, were built to house staff, and one-story, two-bedroom bungalows were erected for physicians; all these structures were located on the east edge of the campus. Pictured here are two employees having their morning coffee in 1956. Staff housing was slowly phased out, but 250 employees still lived on the grounds in February 1968. Three months later, it was announced that all staff housing would end October 1, 1969. (Courtesy of MHSMRM.)

The hospital dealt with staff shortages, especially during wartime. In 1945, wages were increased in order to attract more attendants. Pictured is Manteno mayor Gerald Jarvis signing a proclamation to establish March 11–17, 1973, as Nurses Week to encourage people to enter nursing and "contribute to the well-being of our citizens." In addition to Jarvis are Helen Tober (seated, left) and Aline Bourland (seated, right). Only four of the five standing are identified (order unknown): Pat Spaulding, Linda Dixon, Mary Ella Dixon, and Betty Coleman. (Courtesy MHSMRM.)

This building housed the state hospital's fire, ambulance, and security staff. It was centrally located near the administration building (in the background at right) so that emergency personnel could quickly access various points of the campus. Many young men from Manteno worked as ambulance drivers, the skills for which did not necessarily include those of an emergency medical technician. Rather, they needed to know how to drive safely, sometimes transporting patients to hospitals near or in Chicago. (Courtesy of Phil Tkacz.)

Spaces for staff to relax while on hospital grounds were few, and emergency personnel needed to stay close to their station. Therefore, break time for these employees was spent with a well-placed pool table in the back of the fire station garage. (Courtesy of Phil Tkacz.)

In early 1985, with Manteno Mental Health Center (MMHC)—a major employment center for the area—scheduled to close, a nonprofit group was formed called the MMHC Redevelopment Council with the goal of repurposing the campus for multi-use light industry. On January 1, 1986, ownership of 202 acres shifted from the state to the nonprofit, and Illinois Diversatech had its beginning. Led by Francis J. Smith, industries began moving to the Diversatech campus. Also in 1986, Manteno Veterans Home opened, repurposing six cottages in the northeast corner of the campus. Pictured above in 2019 is Veterans Home Building 1 (MMHC's old Hunter Cottage). Wings that used to be filled with tens of beds out in the open for MMHC patients have been renovated so that veterans have enclosed rooms similar to nursing homes. The old day rooms now offer common areas for eating or activities. Above-ground hallways were built ("the Interconnect") so that all buildings that house veterans are connected. Pictures of veterans who have lived there line the Interconnect's walls. Below is one of the porches with room for wheelchairs, visitors, and beanbag boards. (Both, author's collection, photographs taken with permission.)

Part of state mental hospitals' strategy for treating patients included activities such as arts, crafts, and games. Patients even played in a nine-piece orchestra and went on campouts (escorted by staff) to the Kankakee State Park. A nine-hole golf course, built in the early 1960s, was another form of amusement therapy. Years later, this was turned into a municipal golf course. (Courtesy of Annette LaMore.)

This 2014 image shows the tree-lined lawn in front of the old administration building. In 2019, HomeStar Bank still occupied it, but a merger would soon erase its name. The old tunnels are no more, filled in to ready the campus for new life. An electrician working in 1986 saw work areas still filled with tools, as though workers would be right back. Buildings not repurposed have been razed; still standing are the ones purchased by various industries. About 4,000 patients remain—in a cemetery that includes seven babies who died at birth between 1946 and 1976, buried among those who called Manteno their home. (Author's collection.)

Eight

Packard Laws

Many 19th century laws in the United States were discriminatory at best and inhumane at worst. One such law stated that a married woman could be committed to an insane asylum upon the word of her husband, without the evidence of insanity required in other cases. When Elizabeth (Ware) Packard moved with her minister husband, Theophilus Packard Jr., to Manteno in 1857, events unfolded that would change her life and ultimately influence laws across the nation and practices of the emerging field of psychiatry.

Elizabeth's journey could have begun in Massachusetts, where she lived with her husband from 1839 to 1854, or in Iowa, where they lived in 1855. But Theophilus's sister Sybil Packard Dole (wife of Abijah Dole) lived in Manteno, and the Presbyterian church needed a minister. Thus, it was to Manteno that the Packards moved in October 1857, so that this village became the backdrop of marital discord and religious intolerance that culminated with Elizabeth being confined to the Illinois Hospital for the Insane for three long years. Historians point out that if the Packards had stayed in New England, where reform movements were taking place at that time, Elizabeth would probably have been among those working for social reform including women's rights. A rural Midwestern town such as Manteno did not afford her this opportunity. Also, the fact that her parents and siblings still lived in the east meant they could not help as events unfolded.

Elizabeth's father, Rev. Samuel Ware, hosted traveling intellectuals and clergymen in his home, with lively discussions to which Elizabeth was allowed to listen. As a result, she grew up to respect individual thought. Theophilus had also been raised by a minister father, but one who discouraged discussion of alternative ideas on religion. Eighteen years of marriage to Theophilus had not changed Elizabeth, and after contact with other religions, she began questioning her husband's Calvinist beliefs. After she converted to Methodism, attending church in Manteno, Theophilus thought his wife would "corrupt" their children with her views, so he had her committed to an asylum. What ensued was a battle that included a Kankakee County jury who found her sane and the emergence of a born reformer: Elizabeth Parsons Ware Packard. She went on to lobby legislatures across the country. The result became known as the Packard Laws, the effects of which impacted countless lives.

This image of Elizabeth Ware and Theophilus Packard Jr. was taken well before June 18, 1860, when he had her physically removed from their Manteno home, carried to the depot, and put aboard a train headed south to Jacksonville, Illinois. Some of Elizabeth's friends and neighbors wanted to intercede as they watched from the train platform but were told that Theophilus had legal paperwork to support his actions (this statement was later questioned). Also, it was the custom of the time not to interfere in matters between a husband and wife. Theophilus escorted Elizabeth on the day-long train ride; she spoke with other passengers, and at least one offered to help her escape. She declined, not wanting to act insane. When they arrived at the Illinois Hospital for the Insane, Theophilus had his wife committed. Without the privilege of letters to family, her exit was blocked for three years. (Courtesy of the Bancroft Library at University of California-Berkeley.)

Pictured is Jacksonville asylum's main building, a huge stately structure. Superintendent Dr. Andrew McFarland was given a petition that Theophilus Packard had asked fellow church members to sign stating that they heard Elizabeth question their doctrines and considered her insane. She was treated well at the beginning of her stay, even trusted with keys to certain hospital areas, but when she spoke out against the mistreatment of patients, McFarland transferred her to a violent ward where she remained until her release in 1863. (Courtesy of Jacksonville Public Library.)

A January 1864 petition presented to Kankakee County judge Charles Starr described how Elizabeth was imprisoned in her home for four weeks. Starr ordered a trial, which took place at the Kankakee County courthouse (pictured here around 1900). Those who testified in Elizabeth's defense included Joseph Labrie, who asserted, "I always said she was a sane woman and say so yet." The jury found her sane. (Author's collection.)

The Home from which Mrs. Packard was kidnapped in Manteno, Kankakee Co., Ill.
"Stranger, please hand this letter to Mrs. Haslet!" See page 20.

Three years after Elizabeth Packard was committed to the Jacksonville asylum, Dr. McFarland declared her "incurably insane" and released her into Theophilus's custody. Having resigned as Presbyterian minister a year earlier, Theophilus wanted to move back to Massachusetts where he could commit his wife to a different asylum. But when he locked her in her bedroom and nailed her windows shut, neighbors intervened. Pictured is Elizabeth's sketch of their Manteno home, with a two-story gable front and two wings. The Packards lived less than a block from Joseph Labrie, who lived on Birch Street. Elizabeth also referred to "Mr. and Mrs. Blessing" as living a quarter mile away; during this time, Isaac and Rebecca Blessing, the owners of the Blessing Hotel, lived on Oak near the depot; thus, the Packards likely lived on or near North Locust Street. (Courtesy of HaithiTrust.)

In January 1864, Elizabeth Packard was vindicated—and homeless, penniless, and childless. Her husband had moved to Massachusetts with their children, assets, and her clothing. She had no legal recourse, except to work for the rights of married women and the mentally ill. She wrote and sold books about her experiences, earning $50,000 over three decades, most of which she spent on travel to lobby for what became known as the Packard Laws. This image of her is from around 1866. (Courtesy of the Abraham Lincoln Presidential Library & Museum.)

Pictured is the old Illinois capitol building in Springfield, which was Elizabeth's first stop on her reform campaign. She began in Illinois and Massachusetts, states that most impacted her liberty. Her belief that women were "non-existent beings after marriage" fueled her work, as did her experiences in the asylum. Illinois amended its commitment law in February 1865, and Massachusetts followed suit two months later. But it was Iowa's 1872 Act to Protect the Insane that became known across the nation as Packard's Law; it included a provision to investigate allegations of false imprisonment or abuse. (Author's collection.)

Elizabeth Packard lobbied throughout the Northeast in 1873–1874 with success. In Washington, DC, she met with President Grant, who endorsed her bill; however, her pursuit of a national law failed in large part due to McFarland, her nemesis from Jacksonville. Next, she lobbied in the Pacific Northwest, the Midwest, then returned east. She maintained a home in Chicago; in 1895, that home was burglarized, and she was beaten. She died in 1897 at age 81. In all, Elizabeth introduced 34 bills in 34 states. (Courtesy of Library of Congress, Geography & Map Division.)

When the nation lost a president in 1865, Mary Todd Lincoln lost a husband. The couple had lost two sons, and another, Tad, died in 1871. When Mary was committed to an asylum in 1875 by her son Robert, Packard's Personal Liberty Law enabled the former first lady to write prominent attorneys James and Myra Bradwell, who helped secure her release. Experts suggest that postal rights for patients was perhaps Packard's most important legacy. (Courtesy of Library of Congress, Prints & Photographs Division.)

Nine
THE RAILROAD'S IMPACT

The railroad was a boon to the village's establishment and growth, but it has also darkened its days. Many have lost their lives on Manteno's railroad tracks. Trains rushing through a sleepy town at speeds up to 70 miles per hour or more have brought about heartbreaking and harrowing stories. This chapter honors those who were impacted by the fact that Manteno began as a train town.

In 1945, the Illinois Central Railroad published the public welfare message "Better late than never. Look Listen Live." By then, trains had been trundling through Manteno for 90 years. The stories of tragedy are numerous. A large accident occurred on September 18, 1893, just north of the village when a Big Four freight train collided head-on with a passenger train. Eleven died. But the Big Four wreck would not be the last head-on train collision in the area. In January 1969, two trains hit head-on just south of Manteno. An accident on March 15, 1999, a mile south of Manteno's border still lives in the memories of area rescue workers; a semi-truck, its trailer loaded with cargo from a nearby steel plant, was hit by a southbound Amtrak passenger train with 228 aboard. A total of 11 died, and 122 were transported to local hospitals.

At Manteno's in-town crossings, three lives were snuffed out within a month in 1963. The youngest had just turned 20—Thomas J. Holmes lived on Oak near the Adams Street crossing. His mother, Cecile (Boisvert) Holmes, was one of the first on the scene after her son's truck was hit by a train. Tom Holmes's parents showed up at a village meeting along with many others. Shortly thereafter, a petition was presented to the Illinois Commerce Commission (ICC), the governmental body with authority over railways in the state. Manteno made it clear: automatic crossing gates were needed. The village was granted a hearing at the ICC's office in downtown Chicago, which was attended by mayor Leo Hassett as well as clergy and business owners who all gave testimony that ultimately brought these mechanical devices to the village. Automatic gates would eventually be taken for granted, but their addition to the landscape was the result of events that occurred in 1963.

This c. 1910 view looks north from West Bros. Elevator, which was on Main Street, along the railroad tracks just south of Division Street. In 1900, Alfred LaRocque was killed by a train car from a "flying switch." This high-risk maneuver, eventually outlawed, involved uncoupling cars from the locomotive "on the fly" and letting the rolling cars enter the switch. This scene shows a pedestrian walking along the tracks not at a crossing, which can also spell trouble. After pleas from the village, the railroad posted watchmen in 1908 at the "North" (Third Street) and "Depot" (Division Street) crossings. These men used hand-held signs or lanterns to stop traffic when a train came. Watchmen were not posted 24 hours a day; if they were not on duty, people were on their own. About the same time that the interurban trolley was set to close in 1927, flashing red lights at the crossings took the place of watchmen. But there were still no automatic crossing gates. (Courtesy of MHSMRM.)

This c. 1910s image, looking east, shows a railroad crossing in the village with an interurban trolley in the background. The trolley track entered town on the east side of the Illinois Central mainline (visible in the foreground), ran along Oak Street, then stopped at the interurban depot on the southeast corner of Oak and Division Streets. The absence of a guard shack suggests that this is the Adams Street crossing. The sign at right warns motorists and pedestrians of the crossing. The first US patent for a crossing gate dates to 1867; its mechanism involved underground cables or chains between the gates and the gatekeeper's crank. There is no record of this type of gate having been in Manteno. The cost of installation would have been prohibitive. (Author's collection.)

139

Milo Peters, pictured here in 1906, was an early settler, lumberyard owner, and builder. In September 1909, He and his wife, Ellen (Richardson), of 50 years were returning home after a moving picture show. As they crossed the tracks, Milo ushered Ellen across but misjudged the speed of the train from its oncoming headlight. The train hit him; he was thrown and killed. Reportedly, the railroad and village were censured after the accident for scant protection at the crossing. Already elderly and having witnessed her husband's tragic death, Ellen Peters died months later. (Courtesy of MHSMRM.)

This mid-1930s image shows the gas station opened by Stanley and Claude Mann at Main and Division Streets (facing Main), along the west side of the tracks. The Division Street crossing is in the background at left. At that time, only "crossbuck" signs (an "X") and flashing lights warned motorists and pedestrians of oncoming trains. Claude Mann sold this gas station in 1941; it was later razed. (Courtesy of MHSMRM.)

This 1960s ICRR freight is the type that traveled through Manteno. Even without automatic gates at crossings, not all encounters with trains proved fatal. Jerry Jarvis survived a train that hit (and carried) the front section of his car in 1954. Two other incidents (1961 and 1964) involved trains that clipped vehicles, spinning or knocking them aside. In the case of pedestrians, a family of three were walking on the tracks atop Rock Creek bridge when a southbound Amtrak approached; the engineer slowed to a near stop and the pedestrians, startled but safe, crossed the bridge to safety. (Author's collection.)

Thomas J. Holmes, pictured here in 1961, was struck by a passenger train at the Adams Street crossing in April 1963. Two others had been killed at the Third Street crossing weeks earlier: Ethel Farris and Lois Jackson, a mother and daughter. The entire town swung into action, and a hearing was held with the Illinois Commerce Commission on May 24, 1963. What followed made history and ultimately made the village safer. (Courtesy of Patricia C. Holmes Pearce.)

The Manteno News

No. 14 Manteno, Ill., Thursday, November 21, 1963 Ten Cents

Railroad Gates to Be Installed By Nov. 1964

The Illinois Commerce Commission has directed the Illinois Central Railroad to install gates at all three village crossings before Nov. 4, 1964.

Cost to the village of installing automatic gates at the Adams Street railroad crossing is not to exceed $8,000, village board members learned Tuesday night.

A warning bell also was ordered at the First Street pedestrian crossing.

The state will pay 90 per cent of the cost of the Division and Third Street crossing gates and 50 per cent of the Adams gates, with the Adams cost not to exceed $8,000. The village is to pay 50 per cent of the Adams

of public works, noted that tons of waste paper at the village dump cause litter when winds blow them away. Kerouac reported that the firemen are planning to burn the papers.

Clerk Henrisy reported that the village treasury has benefited from August motor fuel gas tax receipts of $1,087.01 and from August sales tax receipts of $1,272.10.

It took 111 years from the time Manteno Depot opened until automatic gates were installed at village crossings. After three deaths in the space of a few weeks in spring 1963, village officials and citizens appeared before the ICC, whose decision called for the installation of gates at the two north crossings and the closure of the Adams crossing. Manteno filed an appeal based on expected growth in the southwest quadrant of town, churches and schools located near the crossing, and many state hospital workers who crossed the tracks each day as they traveled to work from their homes west of town. Three hospital employees were killed in a train/car collision in 1948. Two more, husband and wife Lindell and Idell Sullivan, were killed in 1962. The appeal worked, and the ICC directed that gates be installed at all three village crossings by November 4, 1964. (Courtesy of Chris Russell and the *Vedette*.)

Automatic gates were installed in 1964 at the three in-town crossings; however, a half-mile north and south of town the crossings were still unguarded. In January 1965, Wilbert "Jack" and Gladys (Yeaman) Curl were struck and killed at the lake crossing. It would be four more years until gates were added there. Pictured is the memorial card from this husband/wife double funeral mass. (Courtesy of MHSMRM.)

Wilbert L. Curl
1916 - 1965

Gladys Curl
1920 - 1965

Services from
Manteno Methodist Church
Thursday, January 7, 1965
2 P.M.

Clergy
Rev. Harry Dovenspike

Music
Mrs. William Mansfield
Mrs. Paul Kirkpatrick

Pallbearers

Donald Baird	Gregory Rasmussen
Leroy Johnson	Robert Adwell
Orville Helgeson	David Heintz
Lee Perkins	Jerry Curl
Isadore Ruder	Robert Curl
Ottis Wasson	Raymond Curl

Head-On Crash Near Manteno Injures 47

An Illinois Central passenger train crashed into a stopped IC freight train at 12:35 a.m. today three miles south of Manteno, killing three persons. The third victim is missing and is believed to be buried under the entangled wreckage.

Forty-seven persons were injured, 18 seriously enough to be admitted to hospitals.

THE PASSENGER train was southbound and the freight was northbound. State Trooper James Ashbrook said crew members from the freight said the train was on the far eastern side of three tracks and had stopped to allow the southbound passenger train to go by on the middle track. The track the freight was on ends at the point where the collision occurred and only two tracks go north.

But the freight's engineer, possibly because of the heavy fog

STACKED UP CARS AND COACHES FORM THE AFTERMATH OF IC FREIGHT-PASSENGER WRECK.

Two events in January 1969 expanded the history of trains in Manteno. One was a collision between two ICRR trains south of town, one freight, one passenger (pictured). A total of 47 were injured and 3 killed. That same month, it was announced that automatic gates would be added at the lake crossing. ICRR, the State of Illinois, and the Manteno Road District reached an agreement: Manteno and the state would provide money for the equipment, and ICRR would install the gates. (Courtesy of MHSMRM.)

Robert Lee "Bobby" Taylor Jr. was killed on July 3, 1969, when he rode his bicycle around downed gates at the Third Street crossing and was struck by a southbound freight train. Kids were playing baseball at Legion Park 100 yards away, and people in their cars at the busy intersection were waiting for the oncoming train to pass. The events of that day live on for many. Bobby, pictured here just before the accident, was 15 and had just finished his freshman year at Manteno High School on Poplar Street. (Courtesy of Manteno Community Unit District No. 5.)

Manteno has always been a train town. Even though they no longer stop for passengers, the fact that trains slice through the busiest part of town has not changed. A reminder of the dangers occurred on May 30, 2019, when a pedestrian, Howard Blogg, was killed at the Adams Street crossing. It was his 83rd birthday. Railroads run safety campaigns to promote vigilance among those who traverse its tracks. Every citizen, every parent, every teacher, and every person in a position of authority can remind those around them to "Look. Listen. Live." (Author's collection.)

Ten

Small Town, Big Future

This chapter's title reminds Mantenoans of the slogan that won Darrell LaMore first prize in a 1965 contest; those four words graced the town's welcome sign for many years. It took decades, but the slogan came to fruition—Manteno more than tripled in size since 1965.

As the Greek philosopher Heraclitus made clear, change is constant, and Mantenoans have seen much; from telephones consisting of wire strung between two diaphragms (Skinner's home and store were connected in this manner around 1883) to party lines and private lines. Many remember five-digit telephone numbers that began with "8." In 1958, Manteno became part of the telephone company's Howard exchange, which meant all phone numbers began with H-o ("H" is 4; "o" is 6).

In January 1968, mayor Leo Hassett said that with the opening of Interstate 57, Manteno was "in the path of predicted growth." Many were thrilled with the corridor that would connect them to Chicago or to the Mississippi River. Others were not. Dr. Raymond Malott, a longtime resident and respected physician, said, "It cuts across our prime area of residential growth, but our pleas for it to be built farther out were unheeded; we have to accept the reality . . . and make the best of it." Malott was correct. Homes along Park Street extend west, then stop; west of the freeway, the march of homes picks up and continues. Although those homes are within the town's boundaries, speeding vehicles separate them from their neighbors to the east.

As Manteno's dependence on the railroad ebbed, trains stopped pausing for passengers. In 1958, trains stopped once per day in each direction. By 1968, rail ranked last among all regulated carriers nationwide, and Illinois Central (which became ICI in 1963) was abandoning low-usage lines. The arrival of orange and white ICI customer service vans rendered small-town depots obsolete. Passenger revenue continued to drop, and by 1970, ICI questioned its role in public transportation that was not profitable; it deemed it a social service to be provided by the government. An act signed into law in October 1970 directed the creation of a national rail network; Amtrak went into effect May 1, 1971. By then, Manteno's old depot sat mostly empty.

The village, township, and schools have been the cradle of many a big future. Some stayed, while others followed their dreams elsewhere. Manteno has fostered great expectations for those who have dwelled within its borders.

This 1974 aerial view of Manteno shows a complete lack of businesses or homes along Interstate 57, which opened in 1969. Predictions that the freeway was in the way of residential growth were correct. Fifty years later, a solid line of homes hugs the east side of Interstate 57, while on the other side additions have been more commercial. This map shows the parallels between the railroad tracks, Interstate 57, and the streets that made up the original plat of the town. Note how few roads run true north-south or east-west because of their orientation to the tracks. The Phipps farmstead is visible in this image. The lane that led to their home ran west of Elm Street (an extension of the half-block Lane Drive, so named because it was part of that farm's lane long ago). The lane south of West Cook Street for the old Wright creamery is also easy to pick out. And farthest south on Elm is the first house in what would become Wright Estates; before this, the corner of Cook and Elm was the southwest edge of the village. (Courtesy of KCMPA.)

The village of Manteno grew immensely in just three decades. Its population in 1984 was almost 3,000, and by 2014, it grew to about 9,000. This 2014 aerial view of the village, with an airplane wing in the foreground, shows immense growth. This photograph was taken from the north end of town, looking south. The wing is pointing toward Lake Manteno (note the houses that line the western edge of the lake). Moving from the lake to the right (west) is a 50-acre tract of land that is currently empty. Moving farther west, note how the land along Interstate 57 has filled in, and farmland has disappeared. When it comes to farming, Manteno is a microcosm of the larger American landscape, which has evolved into fewer, larger operations. In 1970, about 4 percent of America's employed workforce were in agriculture; by 2000, that number was 1.9 percent. The reason for this change is multi-faceted—from droughts to technology to public policy. Selling off farmland has not always been by choice. (Courtesy of Bryan Spangler.)

Village hall has moved around since the town was incorporated. By 1939, it was inside the historic waterworks building, facing the alley. Looking back to 1854, the alleys a half-block from Main and Oak Streets (between Third and Division Streets) were part of the original plat filed by David Neal. Those extra-wide/paved alleys are taken for granted, but looking through history's eye, they functioned more as streets at one time, with village hall on one and Henrisey Machine Shop on another (off Oak Street). In 1948, an addition was built onto the east side of the waterworks building, which included a 32-by-40-foot meeting room. Below, that addition is visible between the original structure and the later addition on Main Street. In 1961, a 34-foot extension facing Main Street resulted in the building shown above. By the 1990s, the old Arseneau barbershop at Main and Second Streets had been razed, and the Leo Hassett Community Center was built. Later, the village hall addition on Main Street was again renovated and converted to the police department. Village officials are now housed at Third and Locust Streets. (Above, courtesy of MHSMRM; below, author's collection.)

This steer-drawn covered wagon was part of the 1956 parade for the town's homecoming celebration, which was held in mid to late July in the 1950s and 1960s. Manteno's American Legion sponsored the parade for many years; it also hosted the carnival in the large five-point intersection adjacent to its property at Walnut and First Streets. (Courtesy of MHSMRM.)

Manteno's parades have evolved quite a bit. Pictured is the fourth annual golf cart parade held in June 2019. Golf carts were given the green light by the village in 2010; today, they can be used on certain streets with a permit. (Courtesy of Tina [Shreffler] Dumontelle.)

Dr. Orvan Abijah Phipps and his wife, Jennie (Peck), moved to Manteno in 1919 with their two children Ogden and Margaret. In 1915, Frank M. Wright and brother Charles owned much of the land in the south and west parts of Manteno. Phipps purchased land from them and built the stately home pictured above soon after his arrival. The two Ionic columns in front are patterned after Greek classical architecture. A hitching post for horses is visible, though the animals likely were tied up farther from the home. The Phipps's address was Elm Street for decades, but with development of the land, it is now 255 South Poplar. New houses blotted out the lane that once connected the home to Elm. Criteria for annexation into the village requires that acreage be set aside for parks or schools. The developer set aside former Phipps land for an elementary school (opened 2000), visible in the background above. Nearby is Heritage Park with a plaque honoring the Phipps family. Pictured below is the elementary school in 2019; it serves grades five through eight. (Above, courtesy of MHSMRM; below, author's collection.)

Early village council meetings had to contend with the need for a village waterworks system; without it, homes, churches, and businesses burned with alarming regularity. An ordinance allowed for the building of this stone structure in 1897 (facing the alley a half block west of Main Street) to house two 36-foot pressure tanks and the machinery for a pneumatic waterworks system run by a 10-horsepower gasoline engine. The ordinance also called for hydrants and water mains to be laid between Hickory and Locust Streets and north to Fourth Street and south to Adams Street. (Author's collection.)

The village opened a family-friendly plaza called the Square on Second in 2017. The juxtaposition of the old and new is apparent in this 2019 image—children play in the splash pad in the foreground as the 1897 waterworks building forms a backdrop. The forefathers whose names are etched into the stone building would be proud to see how far the village's waterworks have come; those names include Z.E. Marceau (president), G.W. Diamond, W. Moat, A.G. Trudeau, C.F. Reed, S.V. Duquet, F. Dole, and J.B. Minsier Jr. (clerk). (Author's collection.)

A postmaster used to ring a bell to let Mantenoans know the mail was available for pickup. That practice vanished as the settlement grew. Back in the days when each town had a rail station, Rail Post Offices were aboard trains, and clerks sorted mail as they rolled along. The truck pictured above with "Z.L. Trepanier" on its side transported mail bags from the train station to the post office, which itself moved around town according to who was postmaster. Sometimes the post office was on Main Street, and sometimes it was on West First Street. Rural mail routes existed by the 1920s, but it wasn't until the spring of 1958 that house-to-house mail delivery began in the village. Before that, all residents had post office boxes. In December 1958, the post office opened in its present location at 157 North Main Street. Pictured below is the rear of that building with a line of the now-ubiquitous mail trucks that are standard nationwide. Gone are the days when a mail carrier's name graced a truck's door. (Above, courtesy of MHSMRM; below, author's collection.)

The Louis Towner home, built around 1898, has a storied history. It was scorched when the two-spire Catholic church across the street burned down in July 1898. It served as a dormitory for students and nuns from the nearby parochial boarding school and later became a rectory for St. Joseph's resident priest. It remains a rectory to this day. Louis Towner was a grocer who later served multiple terms in the Illinois Senate (1902–1923). He also wrote a column for the *Kankakee Gazette*. Note that what appears as a turret in the above image was more of a cupola built into the deep roof. This cupola is gone, but the rest of the home is unchanged, including the northeast corner porch with steps leading to a sidewalk that angles to the corner of Main and Baker Streets. (Above, courtesy of Dorothy Marie des Lauriers; below, author's collection.)

William H. Harvey, who was once station agent for the Illinois Central Railroad in Manteno, married Margery Peters, the daughter of early settler and lumberyard owner Milo Peters, in 1884. After their son Clyde was born in 1896, the Harveys lived in the train depot while having a home built at 221 West Division Street (left). Though a front porch and east addition are apparent, the home is recognizable today (below). William Harvey went on to become a business owner; he was village president from 1931 to 1937. He suffered a heart attack while still in office as mayor in February 1937, his duties ended in April, and he died of a stroke in June. It is said that all Manteno businesses closed on the day of his funeral—all except for the funeral home that bore his name. (Left, courtesy of MHSMRM; below, author's collection.)

Joseph Bourelle, who came from Quebec in 1840, became one of Manteno's first landowners when he purchased farmland southeast of the village. With his wife, Souphranie (Delude), he built a farmhouse around 1870–1880. More than 100 years later, new owners of the land no longer wanted the structure and offered it to a Bourelle descendant, Paula (Merwin) Jett, who had the home lifted from its foundation and moved in 1988. The journey from farm to village included narrow country roads and a bridge that the uprooted house barely cleared. Restored to its original state, including reopening the enclosed front porch, it sits at 158 North Oak Street. (Both, courtesy of Janet Ouwenga Sorensen.)

A&P grocery opened on Main Street in 1923, then moved in 1946 to a newly-built brick building on Division Street. The entrance to A&P was at the alley (seen above at left). When A&P closed in 1969, the library leased the building, making it its first (and still current) permanent home. The library had previously popped up in various locations, even in the back of a barbershop. The Manteno Community Library Association had formed in December 1961, and managed the library from its new location on Division Street, using only the east half of the building since the west half was occupied by merchants. In 1981, the library bought out the businesses and expanded into the entire building. Two separate renovations led to the structure that stands today (below). The old shared entrance on Division Street was bricked up, the alley entrance was abandoned, and a west entryway was built. Later, a south addition doubled the library's size. Where four homes once lined Walnut Street south from Division Street, there is a parking lot that allows visitors to come and go safely. (Both, author's collection.)

The above 1931 image shows Bloom School, a one-room schoolhouse that was southeast of the village on Blue Gill Road in Rockville Township. Many Mantenoans were taught within these walls. As has happened throughout the town's history, this structure was uprooted and rolled to a new location. In 1991, the Manteno Historical Society, with the help of Don Fletcher, Melvin Marshall, and Wendell Marr, arranged to have the school moved to the grounds of the society's museum at the corner of Third and Hickory Streets. The below image shows it in its current location. Groups of children tour the building during the school year. It is also available for public viewing during regular museum hours. (Above, courtesy of MHSMRM; below, author's collection.)

This team from Manteno High School was declared "girls volleyball winners" in 1949. From left to right are (seated) Irma Payne, Louise Smith, Jeanne Switzer, and Emlyn Jackson; (standing) Marilou Funk, Doris Piper, Miss Smith (coach), Claretta Weber, Rita McGrath, and Ruth Erickson. (Courtesy of Manteno Community Unit District No. 5.)

The Illinois High School Association promotes interscholastic competition for 800 schools statewide. Female teams were allowed to compete beginning in 1972 with tennis, and soccer was added to the list in 1988. Manteno High School's girls' soccer team, pictured here, won the 2014 state championship. Some of those pictured are Emma Shores (front row, wearing black shorts), Jordan Shipp (front row, third from right), Brianna Barth (back row, third from left), and Sophia Schnitzler (back row, fifth from left). (Courtesy of Manteno Community Unit District No. 5.)

Bibliography

Burroughs, Burt, and Vic Johnson. *The Story of Kankakee's Earliest Pioneer Settlers*. Bradley, IL: Lindsay Publications, 1986.

Carlisle, Linda V. *Elizabeth Packard: A Noble Fight*. Urbana, IL: University of Illinois Press, 2010.

Guimond, Virgil. *A History of Manteno Township, 1740–1990*. Manteno, IL: 1991.

Godfrey, George. *Watchekee (Overseer): Walking in Two Cultures*. Athens, IL: Nishnabek Publications, 2013.

Johnson, Vic, and the Bourbonnais Grove Historical Society. Images of America: *Bourbonnais*. Charleston, SC: Arcadia Publishing, 2006.

Klasey, John, and Mary Jean Houde. *Of the People: A Popular History of Kankakee County*. Chicago, IL: General Printing Co., 1968.

Packard, Elizabeth Parsons Ware. *Marital Power Exemplified in Mrs. Packard's Trial, and Self-Defence from the Charge of Insanity*. Chicago, IL: Clarke & Co., 1870.

Sapinsley, Barbara. *The Private War of Mrs. Packard*. New York, NY: Paragon House, 1991.

Stover, John F. *History of the Illinois Central Railroad*. New York, NY: Macmillan Publishing, 1975.

Viall, Evelyn, and Madge Merwin. *Area History of Manteno, Illinois, 1800s to 1900s*. Dallas, TX: Curtis Media, 1993.

Discover Thousands of Local History Books
Featuring Millions of Vintage Images

Arcadia Publishing, the leading local history publisher in the United States, is committed to making history accessible and meaningful through publishing books that celebrate and preserve the heritage of America's people and places.

Find more books like this at
www.arcadiapublishing.com

Search for your hometown history, your old stomping grounds, and even your favorite sports team.

Consistent with our mission to preserve history on a local level, this book was printed in South Carolina on American-made paper and manufactured entirely in the United States. Products carrying the accredited Forest Stewardship Council (FSC) label are printed on 100 percent FSC-certified paper.

MADE IN THE USA